Watercolor
BASICS

Let's Get Started

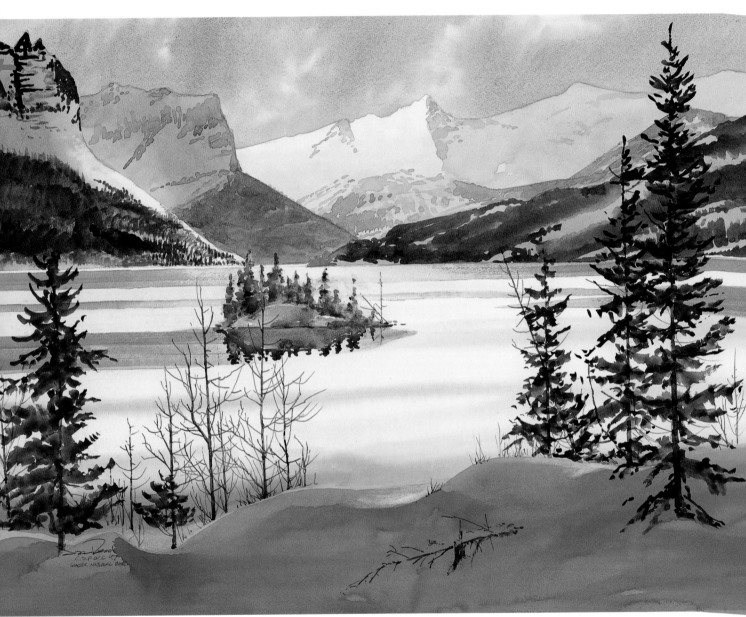

Glacier National Park in Winter
Montana, United States
23″×33″ (59cm×84cm)
Watercolor on Crescent cold-press watercolor board
Collection of Nathaniel C. Stoddard
Toronto, Ontario, Canada

Watercolor BASICS
Let's Get Started

JACK REID

NORTH LIGHT BOOKS
CINCINNATI, OHIO

ABOUT THE AUTHOR

It was as a young boy that Jack Reid became obsessed with images and, at the age of ten, bought his first watercolor painting kit. Money was difficult to come by for a boy growing up in Toronto during the Great Depression, but the young Reid always managed to scrounge up enough to keep himself in paints, brushes and paper. And though goods and services came dearly back then, views and sights were and always will be free. His obsession for watercolor continues today, sixty-three years later.

In 1970 Reid quit his day job as a graphic designer to pursue his watercolor painting full time. It was the right decision. His award-winning paintings are internationally recognized and can be found at such addresses as Windsor Castle and the Savoy Hotel in England. Through outdoor and indoor seminars and television, Reid has imbued more than 10,000 students, young and old, with a passion and love for the medium of watercolor painting. He continues to instruct amateur and professional painters alike in the basic techniques for which he is renowned.

In 1992, Reid was awarded the Commemorative Medal by the Canadian government in recognition for his contribution to the arts. In 1997, he was the artist in residence at Montana's Waterton Glacier International Peace Park. Reid was elected a lifetime member of the Canadian Society of Painters in Watercolour (C.S.P.W.C.) in 1998.

Watercolor Basics: Let's Get Started. Copyright © 1998 by Jack Reid. Manufactured in China. All rights reserved. No part of this book may be reproduced in any form or by any electronic or mechanical means including information storage and retrieval systems without permission in writing from the publisher, except by a reviewer, who may quote brief passages in a review. Published by North Light Books, an imprint of F+W Publications, Inc., 4700 East Galbraith Road, Cincinnati, Ohio 45236. (800) 289-0963. First edition.

Other fine North Light Books are available from your local bookstore, art supply store or direct from the publisher.

10 09 08 07 12 11 10 9

Library of Congress Cataloging-in-Publication Data

Reid, Jack.
 Watercolor basics : let's get started / Jack Reid.—1st ed.
 p. cm.—(Watercolor basics)
 Includes index.
 ISBN-13: 978-0-89134-867-2 (pbk. : alk. paper)
 ISBN-10: 0-89134-867-0 (pbk. : alk. paper)
 1. Watercolor painting—Technique. I. Title. II. Series.
ND2420.R45 1998
751.42'2—dc21 98-4285
 CIP

Editor: Glenn Marcum
Production editor: Amy Jeynes
Designer: Candace Haught

(facing page)
Rainy Day
Haliburton, Ontario, Canada
10"×14" (25cm×36cm)
Demonstration in plein air for students. Watercolor on Winsor & Newton 260-lb. (550g/m²) cold-press watercolor paper
Collection of Mrs. Maggie Reid
Brampton, Ontario, Canada

DEDICATION

This book is dedicated to my wife, the love of my life, Maggie,
whose love and support
are a constant source of energy and inspiration.
I could never have gotten this far in life without her.

ACKNOWLEDGMENTS

I want to thank the following people for their help
and unflagging support in bringing this book to fruition.
Jennifer Beale, who kept after me to write and design
the original version of this book;
Pam Seyring, who discovered my book
and who was the first to present it;
Rachel Wolf, whose guidance I cherish;
my editor, Glenn Marcum; photographer Peter Gerretsen;
and last, but most important, William Shields,
who transcribed this entire book from cover to cover
making sense of my garbled tapes, fits of temperament and
periods of discouragement and despondency.
He persisted even though he must have wondered
if it was worthwhile. Well, thanks to him, it is.

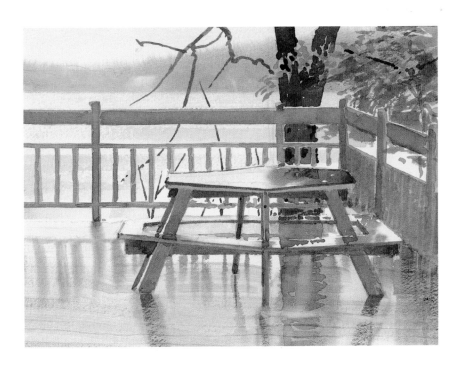

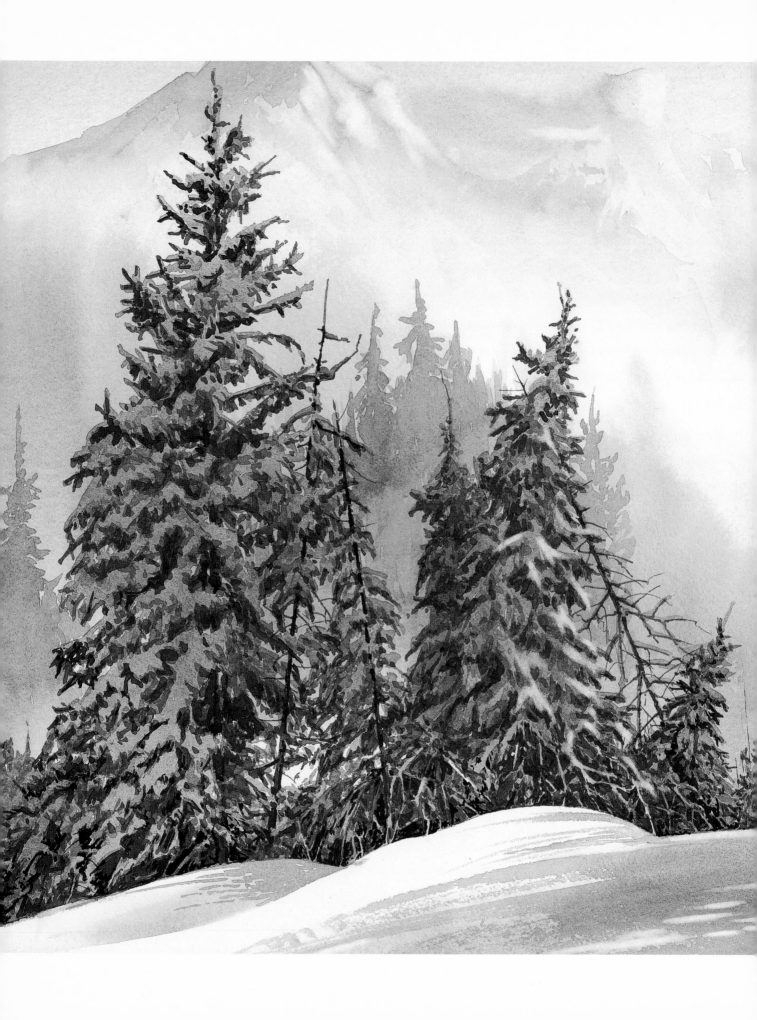

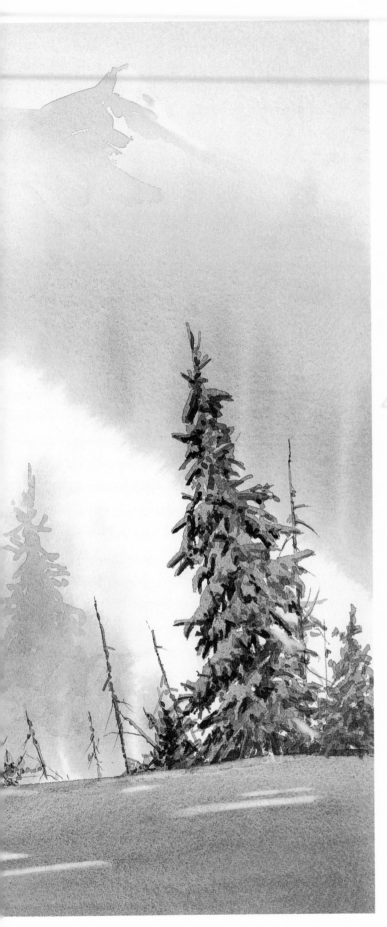

Contents

Sunbreak
Near Invermere, British Columbia, Canada
20″ × 28″ (51cm × 71cm)
Watercolor on Saunders Waterford 300-lb. (640g/m²)
rough watercolor paper
Collection of Mr. Frank Redl
Toronto, Ontario, Canada

INTRODUCTION

I was born in Toronto in 1925 and am blessed with six brothers and five sisters. One of the strongest memories from my childhood is an addiction to drawing and a curiosity about visual images. I was constantly analyzing light and its effects on my surroundings. I became an addict at rendering with pencils, crayons or whatever was available. This was a healthy addiction from which I have thankfully never fully recovered.

When I was ten years old I joined the local Kiwanis Boys Club in Trinity College in Toronto. It was here that I met my mentor, Tom Roberts, a professional watercolor artist. He took a personal interest in me because of my obvious fascination with art. He encouraged me to accompany him on sketching trips. One day, Tom completed a small watercolor of the old St. Lawrence Market in Toronto. He executed this quickly with a brief explanation of composition, values and colors (which were very limited). When he finished, I was completely hooked on transparent watercolor—and have been ever since.

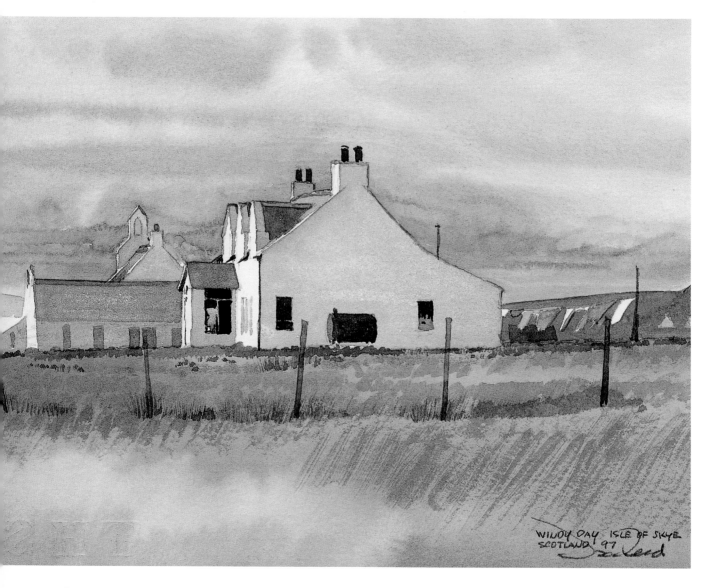

He did not give me theories or synthetic book knowledge, valuable as those may be. What he did do is demonstrate the *how* of watercolor painting in simple terms. The effect was so great that I could literally paint that scene from memory today, sixty years later.

From that day forward, I painted wherever possible, with a real passion. But lacking understanding of the tools and techniques of this medium, I experienced great frustration and discouragement. However, this did not stop me from painting.

One day, in 1957, I was so taken by a scene on the waterfront that I attempted to paint it in color, and of course, it was a disaster. I became depressed; I was trying to do too much with too little knowledge. Fortunately, I remembered that Tom Roberts was living nearby, and I paid him a visit, hoping to find some help. He was very busy but did take a moment to say, "I don't believe that books can teach art. However, there is one that deals in fundamentals and may help you. It's called *Ways With Watercolor* by Ted Kautzky."

I had very little money at the time, but necessity is truly the mother of invention. I saved the money, bought the book, followed the very simple directions as often as I was able and learned one thing above all else: that I needed a complete understanding and mastery of the tools of painting to learn how to express what I wanted in the exciting medium of watercolor painting.

Years later, at the age of forty-five, I began a full-time career in painting. I didn't plan it that way. I only hoped it would work, and it has. Without the support of my dear wife Maggie, my best friend, it wouldn't have been possible. She kept the books, framed pictures, delivered materials and assisted me in countless ways as well as continuing to work her full-time job and keep house. She's been my greatest supporter and I am forever grateful. (I find it amusing that when my wife does the bookkeeping, we make money; when the accountant does, we lose money.)

In conclusion, I want to say that after twenty-five years of teaching thousands of novice watercolorists the simple methods contained in this book, I firmly believe that anyone willing to follow the directions and do the work cannot fail to achieve a successful picture. If I can do it, so can you. After all, you can't graduate unless you go to school.

Windy Day
Isle of Skye, northern Scotland
10″ × 14″ (25cm × 36cm)
Plein air watercolor on Saunders Waterford 200-lb.
(425g/m²) cold-press watercolor paper
Collection of Mr. Murray McPhail
Toronto, Ontario, Canada

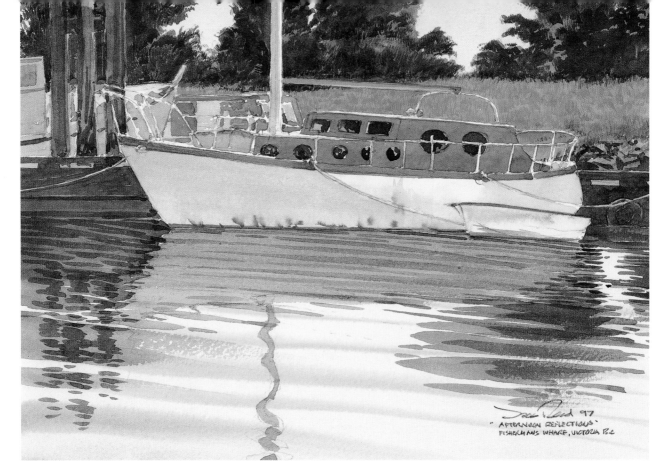

Afternoon Reflections
Near Fisherman's Wharf, Victoria,
British Columbia, Canada
10″ × 14″ (25cm × 36cm)
Plein air watercolor on Winsor & Newton 260-lb.
(550g/m²) watercolor paper
Collection of Mrs. Maggie Reid
Brampton, Ontario, Canada

Here are a few questions often asked by my students. You might like to hear my answers now before you go any further:

Q. I would like to try watercolor, but it is so prohibitively expensive. Couldn't I buy some cheap paper and paint until I see if I like it?

A. Yes, watercolor painting is expensive when you buy the right kind of tools, paper and so on. If you buy cheaper grades of paper and paint, you will never experience any real success. The instructions in this book will show you how to buy the best quality available in a way that is quite affordable.

Q. I have been told that watercolor is too difficult for a beginner. Is that true?

A. No, it is not true. Failure in this medium is usually caused by lack of proper introduction to the paint, paper and brushes. My simple exercises in monochrome (one color) introduce the student to this medium that is tricky and elusive but not that difficult.

Q. I would like to take a workshop, but being in a class with others who are more advanced is intimidating.

A. This book will guide you through practical exercises that will give you confidence, perhaps enough for you to try a workshop. There are many good ones available.

So take the first step and practice, one exercise at a time. Or to put it another way, go as far as you can see, and see how far you can go. Perhaps painting is similar to baseball in this respect: It teaches us to build on errors or, if you like, on our mistakes. The player who hits one in three becomes a legend. How many times must he have failed before he achieved legendary status? He never quits. So it goes with painters: They keep wielding the brush.

Your fellow artist,

Jack Reid, C.S.P.W.C.

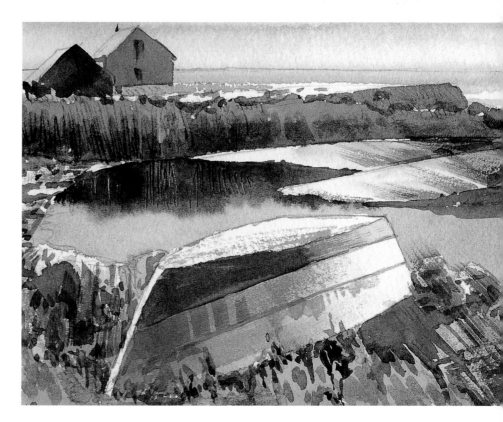

Nova Scotia Tidal Pool
5½" × 7½" (14cm × 19cm)
Watercolor on Winsor & Newton
300-lb. (640g/m²) rough
watercolor paper
Collection of the artist

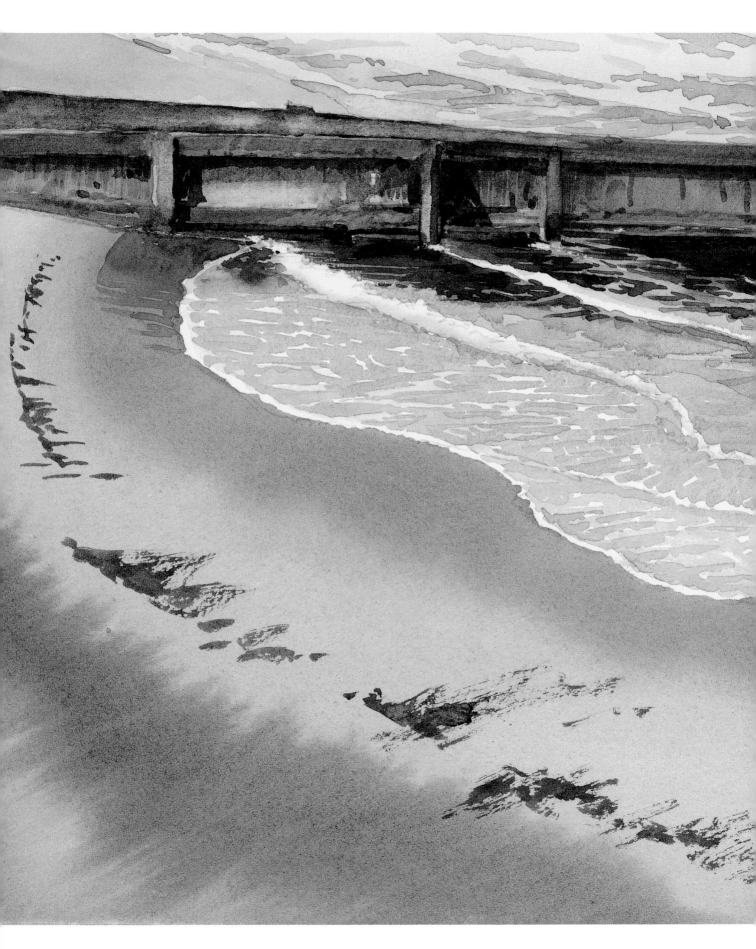

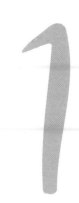

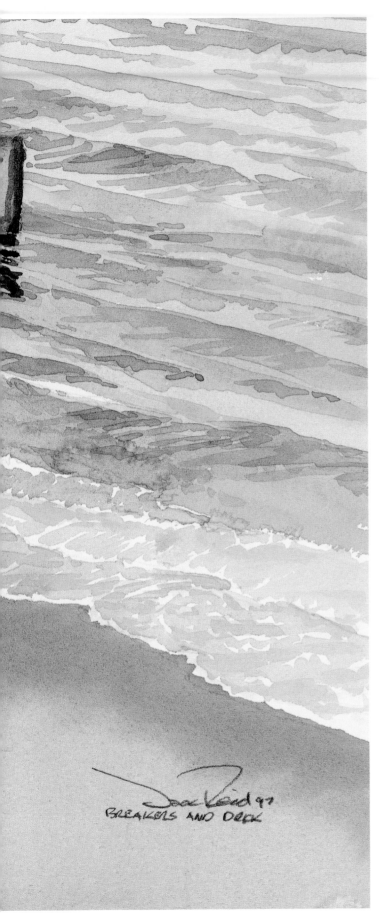

WHAT DO I NEED TO BEGIN?

The most important piece of equipment won't cost you anything at all: attitude. If you're looking for shortcuts or gimmicks, you won't find them in this book. The best kind of attitude to bring to any new endeavor is a firm belief in hard work. Some books promise to make watercolor painting easy and order you to "have fun." Well, I disagree. Though I'll keep things as simple as possible throughout this book, simple doesn't mean easy. You have to work at this marvelous medium the same way a singer must train her voice or a musician must practice his instrument. In other words, you'll need to master the basics. I've always ascribed 10 percent of my success to inspiration and 90 percent to perspiration.

Breakers and Dock
Jamaica, Virginia, near Urbanna, U.S.A.
10″ × 14″ (25cm × 36cm)
Watercolor painted plein air on Saunders Waterford
200-lb. (425g/m²) cold-press watercolor paper

Basic Materials

The materials you'll need to get started in watercolor painting need not cost a fortune. Believe it or not, many of the materials are probably sitting in your house or apartment right now. Put the following on your "need to get" list.

Brushes

All brushes in this book are either square-tipped or round-tipped. Show your supplier these pictures and they'll know exactly what you want (be aware that these brushes are shown smaller than life size). Don't let anyone talk you into something else; insist on brushes that resemble these. Sable brushes are the best but are expensive. I recommend synthetic brushes as they work well and are more economical.

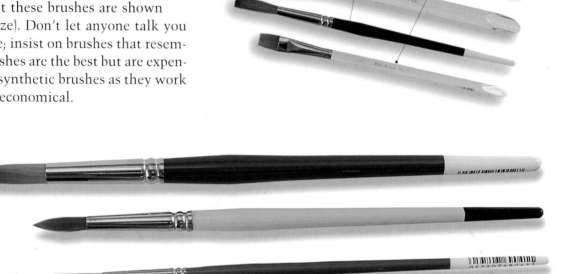

2-INCH (51mm) HAKE BRUSH

1-INCH (25mm) FLAT WASH BRUSH (I USE THIS ONE FOR 80 PERCENT OF MY PAINTING)

SHO-CARD BRUSH (FOR LETTERING AND SQUARE SHAPES)

½-INCH (12mm) FLAT WASH BRUSH

NO. 14 ROUND BRUSH

NO. 8 ROUND BRUSH

RIGGER BRUSH (FOR FINE DETAIL)

NO. 4 ROUND BRUSH

Paint

There are two types of watercolor paint: opaque and transparent. For the exercises in this book, we'll be using transparent watercolor paints because that is what I use. Transparent paints come in two forms: dry pans and moist tubes. Pans are hard tablets of concentrated pigment. They're easier to carry around but take longer to prepare. Moist tubes are convenient because they mix with water quickly. Remember to buy artist-quality paints. Student-grade varieties contain fillers that reduce the color's brilliance.

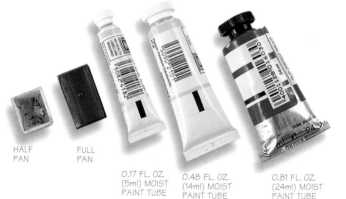

HALF PAN

FULL PAN

0.17 FL. OZ. (5ml) MOIST PAINT TUBE

0.48 FL. OZ. (14ml) MOIST PAINT TUBE

0.81 FL. OZ. (24ml) MOIST PAINT TUBE

The Palette

The palette's work surface and paint wells must be white. Watercolors are transparent and can be seen properly only on a white surface. The order in which I've set up this palette is quite controversial; it's not what a traditional watercolorist would do, but I don't care. I believe that in the lessons to come this palette setup will help you isolate and understand the nature of these colors and their groups. The sponge in the middle is for wiping excess paint from your brush.

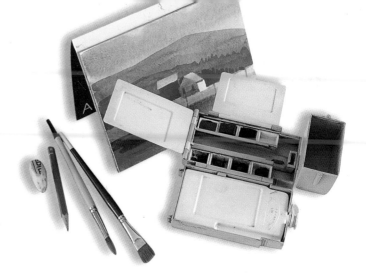

Cotman mini palette with brushes and watercolor paper block.

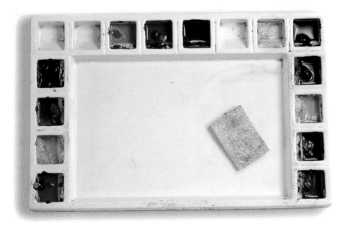

WATERCOLOR PALETTE CLOCKWISE FROM LEFT:

Rose Madder Genuine, Aureolin Yellow, Cobalt Blue, Viridian Green, Raw Sienna, Burnt Sienna, Ultramarine Blue, Winsor (Phthalo) Green, Winsor (Phthalo) Blue, Transparent Yellow, Permanent Alizarin Crimson, Permanent Rose.

The Mini Palette The Cotman mini palette (above) is manufactured by Winsor & Newton. It is a self-contained box that holds ten half pans, a water container and foldout mixing trays and is compact for quick outdoor impressions. It's also called a spit box. Spit boxes got their name centuries ago from British artists who carried dry pigments in a small box wherever they went. When a scene inspired them, they moistened the paint with spit and were ready to go. Modern spit boxes have dry pans of paint, a water bottle and a paintbrush. I've also shown a few small brushes and a 5″ × 7″ (13cm × 18cm) Fabriano watercolor block.

Folding Palettes These folding metal palettes (below) are an alternative to spit boxes. They're equipped with divided sections into which you squeeze and mix moist tube paints.

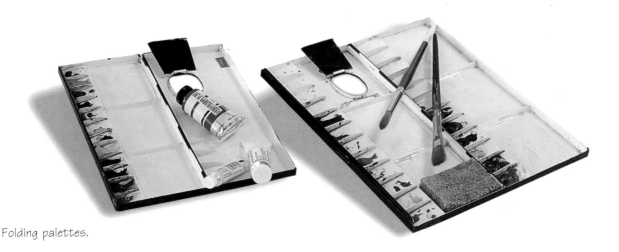

Folding palettes.

Paper

The exercises in this book are done on 300-lb. (640g/m²) rough-surfaced and cold press watercolor paper. Unlike lighter papers (under 200 lb. [425g/m²]), it doesn't buckle when wet, so you needn't stretch it. Basic paper weights are 90, 140, 200, 300 and 400 pounds (190, 300, 425, 640 and 850g/m²), referring to the weight of a ream—five hundred sheets measuring 22"×30" (56cm× 76cm). The three basic paper surfaces are *rough*, which holds paint well and is especially good for wet-in-wet and dry-brush techniques; *cold-press*, a smoother paper, which also holds paint well and is good for drawing on; and *hot-press*, which is extremely smooth. I prefer rough, but whichever you use, don't penny-pinch on paper. Whatever you buy, make sure it's 100 percent cotton, mold-made watercolor paper.

Cold-press and rough-surfaced watercolor papers.

Watercolor Paper Block At right is a watercolor paper block, a pad of 140-lb. (300g/m²) paper gummed around all four sides. A small area is not gummed so a sharp edge may be inserted to remove the completed painting, leaving a fresh sheet ready for the next painting. Buying blocks saves you from having to cut your own paper.

To remove a sheet from the block, just insert a sharp utility knife in the opening provided and cut as illustrated.

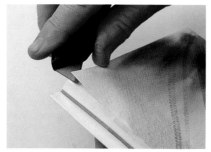

Fabriano watercolor paper block.

Getting the Most Out of Your Paper

Here's a money-saving tip: Whatever kind of paper you use, purchase a full 22"×30" (56cm×76cm) sheet. From this one sheet you can get exactly sixteen separate pieces measuring 5½"×7½" (14cm×19cm) After you mark off the sections as shown, use a straight edge and a sharp utility knife and cut the paper into separate sheets.

This is a full sheet of 22"×30" (56cm×76cm) watercolor paper. It will yield sixteen pieces 5½"×7½" (14cm×19cm) in size.

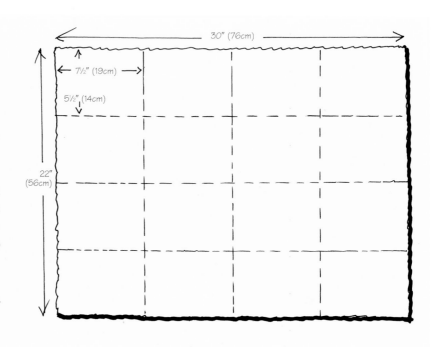

30" (76cm)

7½" (19cm)

5½" (14cm)

22" (56cm)

Accessories

Here are a number of items no watercolor painter should be without. As I said earlier, you can probably find most of them in your home right now.

1. Palette
2. Empty 35mm slide mount
3. ¾" (2cm) masking tape
4. Pencil for sketching
5. White plastic eraser
6. 5" × 7" (13cm × 18cm) sketch pad
7. Two mixing dishes for tube watercolors
8. Paper tissue
9. Coroplast plastic panel (work surface) with 5½" × 7½" (14cm × 19cm) piece of watercolor paper taped to it
10. Cosmetic squirt bottle
11. Double water container
12. Heavy jar to hold brushes

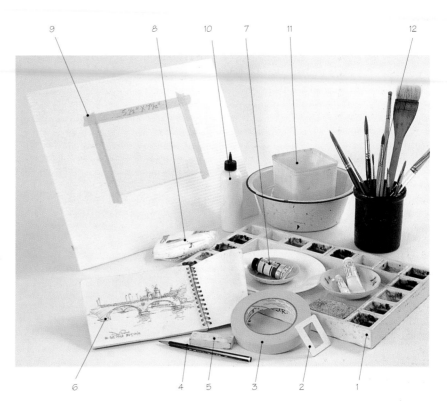

Coroplast Coroplast brand polypropylene sheet is a plastic material that is corrugated like cardboard. You can buy it at your local sign company or art supply store. Light, sturdy and waterproof, Coroplast is a perfect surface to tape your watercolor paper onto, and excellent for outdoor painting trips. You'll notice I use it throughout this book.

Water Containers It's common practice and a very good idea to place one water container inside another. This handy way to work will allow you to spend more time painting and less time fetching clean water. Rinse your brush first in the outside bowl, removing excess paint; then swirl your semiclean brush around the inside container for the final cleaning.

Blow-dryer Any old blow-dryer will do. We will use this to speed up the paint's drying process. It's the only thing I use it for—I'm almost bald.

Utility Knives No watercolorist is without them. We will use them to cut our paper and to add detail to our painting through a technique

known as scoring. You'll want a regular kitchen knife on hand. This is the one you never use because it's so dull it can't even cut water, but it's perfect for scoring. You'll also need a common utility knife to cut your paper. It has replaceable blades and can be purchased at any hardware store.

Spray Bottles I use these to spray mists of water onto pictures, either to keep the paint from drying or to ready an area for more paint. I will not be demonstrating the use of these bottles in this book, but you should be aware of them.

Nesting Trays and Mixing Dishes The nesting trays will hold your paint, and shallow dishes are wonderful for mixing. They have to be white: It's the best color for mixing paints because white is the ideal background against which to view transparent color. Any white china container is suitable for mixing paints.

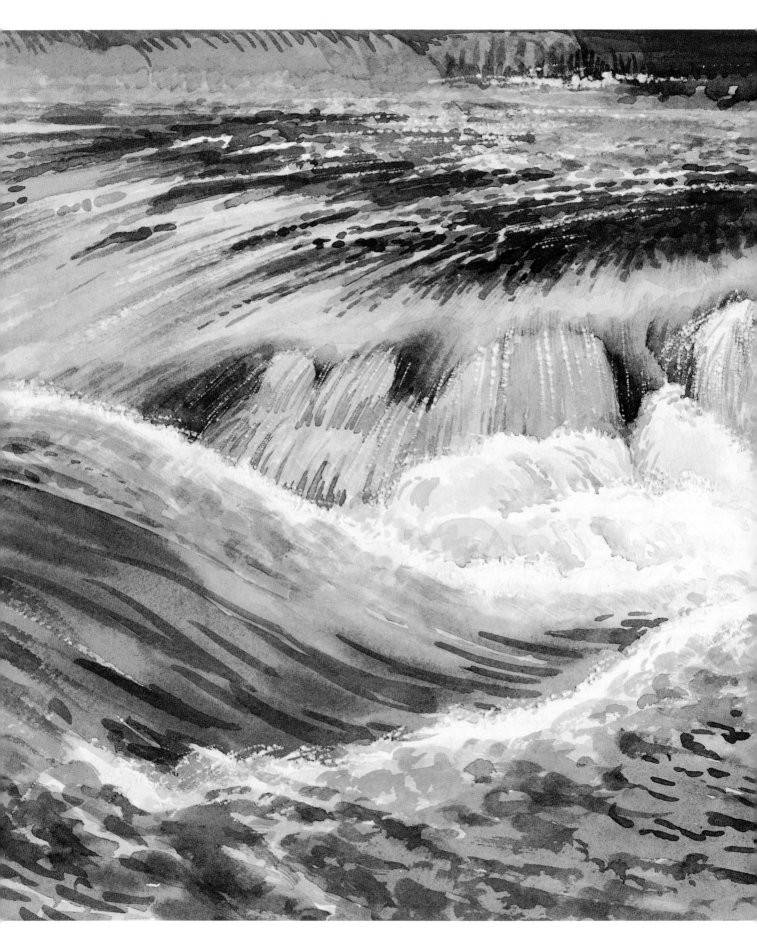

GETTING STARTED

N ow that you have your materials you're probably wondering: "OK. I'm ready to paint, but where do I do it? And how? I've never picked up a brush before! What's the best way to paint outside?" This chapter answers those questions—showing you how to arrange your work space both indoors and out—and provides simple exercises showing you how to hold and control your brushes. It's no different than starting any new endeavor; the first thing you have to do is set up shop and get to know your tools.

Furnace Falls
Study
Haliburton, Ontario, Canada
Watercolor plein air painting on Saunders Waterford
200-lb. (425g/m²) cold-press watercolor paper
Collection of Mr. and Mrs. Jay Paterson
Waterloo, Ontario, Cananda

Where Do I Paint?

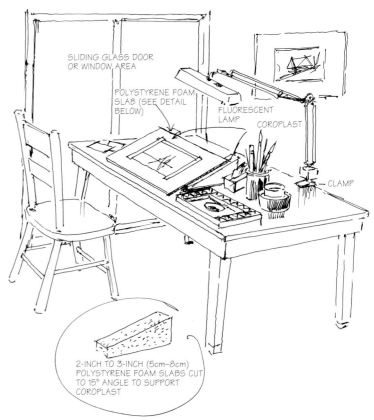

SLIDING GLASS DOOR OR WINDOW AREA

POLYSTYRENE FOAM SLAB (SEE DETAIL BELOW)

FLUORESCENT LAMP

COROPLAST

CLAMP

2-INCH TO 3-INCH (5cm–8cm) POLYSTYRENE FOAM SLABS CUT TO 15° ANGLE TO SUPPORT COROPLAST

Indoors

It's really important that you find a quiet, uncluttered place to paint. Choose a place away from noise and distractions, and lock the door if you can. If the phone rings, tell the caller, "Sorry, I'm in the middle of a wash." If you're a lawyer, though, you may have difficulty explaining that to friends.

Arranging Your Work Area The first thing you need is a table. This could be anything from a piece of plywood to, ideally, a drafting table (that's what I work on). The key, however, is that your work surface be inclined to about a 15° angle. If your tabletop doesn't tilt, you can use polystyrene foam slabs to create this effect, as shown at right.

If you're a right-handed painter, your equipment should be on the right; for lefties, on the left. Brushes, palettes and other accessories should be placed within easy reach. I use Coroplast and ¾" (2cm) masking tape to hold my paper in place.

People seem to get messed up with painting because they're inundated with clutter. In my painting workshop, I insist each student have their own table with lots of elbow room. The same applies to painting at home. Your work area should be next to a window, facing north, for natural light; try to avoid working in direct sunlight, because that can blind you. If you can't set up near a window, the next best thing is a fluorescent lamp,

because they eliminate reflections and diffuse light well, thereby reducing shadows created by your hand as you paint. Ideally, the lamp should contain two 18" (46cm) bulbs—one cool and one warm. Your art supply store likely carries these. They're not terribly expensive. The idea is to have your light source close enough to your painting that a good, even light is thrown onto the work area. Finally, choose a comfortable chair with good back support. I'm a senior, and back support is very important to me.

Outdoors

There are many ways to organize your equipment for outdoor painting. The bottom line is to minimize your required equipment and carry it in a compact form. I use a backpack to carry all my supplies. It's a good idea to line the inside of your backpack to prevent your materials from getting crushed (see the illustrations on the facing page). The basic supplies are: paints, paper, brushes, water and dishes, Coroplast backing and, of course, a sandwich, bottle of wine or whatever bodily supplements you may need for your journey out-of-doors.

For outdoor painting you may want to choose a lightweight folding chair.

Reinforcing Your Rucksack

The method I use for preparing my backpack for comfortable outdoor painting is as follows:

1. Take a large sheet of Coroplast, say 4' × 8' (1.2m × 2.4m).
2. Measure the interior dimensions of your backpack and cut out a pattern slightly smaller than these measurements, according to the diagram below.
3. Score on the dotted lines with a utility knife but don't cut all the way through.
4. Cut through the Coroplast on the solid lines.
5. Fold scored areas to form a box or frame; then tape with heavy-duty shipping tape.

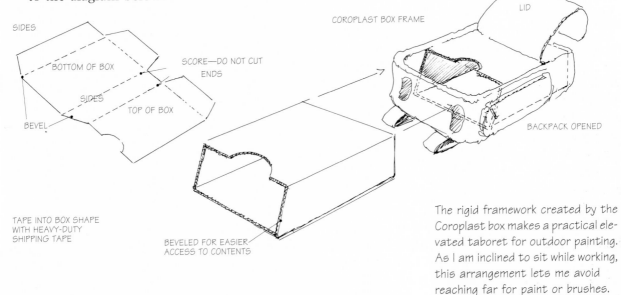

SIDES

BOTTOM OF BOX

SCORE—DO NOT CUT ENDS

SIDES

TOP OF BOX

BEVEL

COROPLAST BOX FRAME

LID

BACKPACK OPENED

TAPE INTO BOX SHAPE WITH HEAVY-DUTY SHIPPING TAPE

BEVELED FOR EASIER ACCESS TO CONTENTS

The rigid framework created by the Coroplast box makes a practical elevated taboret for outdoor painting. As I am inclined to sit while working, this arrangement lets me avoid reaching far for paint or brushes.

Proper Seating Once you are outside at last, you might be happy to sit on the ground or on a log as you paint. Personally, my sore old back needs support. I use a folding chair, and I never leave home without it. You, too, might want to get a lightweight and comfortable folding chair. The next step is to begin unloading your materials. I tape my paper to my portable piece of Coroplast before I leave home.

I then unfurl my brush pouch, set up my work table and other materials and begin viewing the surrounding scene with the aid of an empty slide mount, which helps me compose potential subject areas.

Go Anywhere, Paint Anything A good picture doesn't pop up just anywhere. You have to go out and find it! I can go anywhere with this setup. I throw the backpack on, sling the folding chair onto my back and still have a free hand for climbing over rocks. If I find myself in very close quarters, say, nestled in a craggy coastline, I call the little Cotman spit box palette into service.

How Do I Use These Materials?

You're probably a little nervous about getting started because you don't yet know how to use the paint or the brushes. In this chapter I will take you through a few exercises that will show you how to hold and control the brush. All you need for now are the brushes, some cheap newsprint or an old newspaper (not watercolor paper yet) and one color of paint. You'll learn some simple concepts: Square-tipped brushes paint square objects, and round-tipped brushes paint round objects; large brushes paint large objects, and small brushes paint small objects. That may sound like an oversimplification, but believe me, it never occurs to a lot of people.

Painting with the right size brush means you are painting with the fewest number of strokes. That means you'll still be loose and spontaneous. Once you learn how to control a brush, you can use it to paint all sorts of shapes at will.

Preparing to Paint!

Pick up a brush and hold it so it's comfortable for you. Relax and hold it gently. Imagine it's a small tube of toothpaste. Don't try to paint perfectly; simply experiment with what the various brushes can do. What happens when the brush is full of paint? What happens when it runs out of paint? What effects do you get? Play around, become free and spontaneous; that's what painting is about.

Think of the brush as an extension of your hand. Humans are tool users. Great athletes become great because they master their equipment. Think of a golfer and his club, a hockey player and his stick, a tennis player and her racket—and a painter and his brush. Get comfortable and get acquainted with your brushes.

Now that you have the basics of mixing and brush loading, we're going to lay out some cheap newsprint and get down to business.

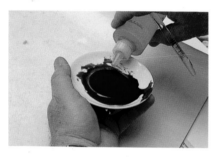

Step 1: Mix the Paint
This is just like cooking. Squeeze a dime-size amount of paint into a shallow mixing dish. Add enough water to make a medium-thick wash.

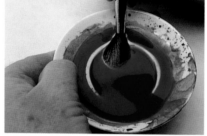

Step 2: Load the Brush
Use the brush (I have a no. 14 round here) to mix the water into the paint. You want an evenly mixed solution so as to prevent blotches. Always make a bigger mix than you think you need.

Step 3: Roll the Brush
Once your brush is loaded, roll it against the side of the dish, applying a gentle pressure to remove any excess paint that might drip onto your work surface—or your lap.

Step 4: Make Your Point
Rolling the brush will give it a nice point for stroking in fine detail.

Round Brush Exercises

Practice painting with a round-tipped brush to see what it can do. Paint straight, squiggly and curved lines with every size of brush. Remember: Relax and have fun.

Banana

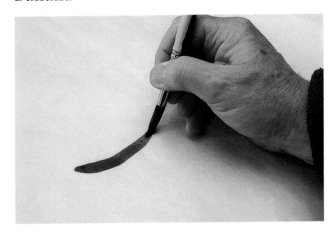

If ever two things were meant to go together, it is brush and paper. Make sure you're comfortable. Take your loaded brush and, with some authority, press it against the paper and begin to drag it away to the right. Let up on the pressure as you approach the end of your line.

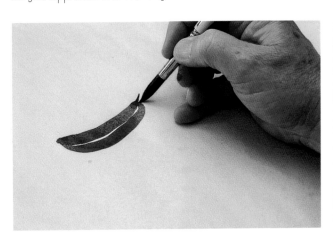

By drawing a similar line just over top of the first one, the banana takes form.

Waves on Water

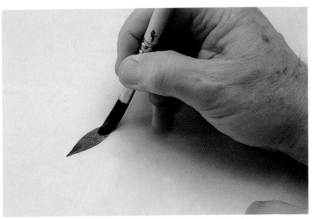

By pressing down on the brush and releasing the pressure, dragging the brush and then repeating this cycle, I produce the effect of waves on water.

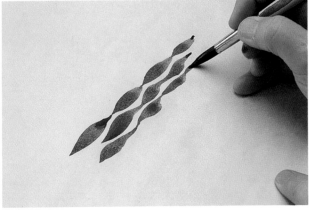

Press, release; press, release. It's that simple.

Maple Leaf

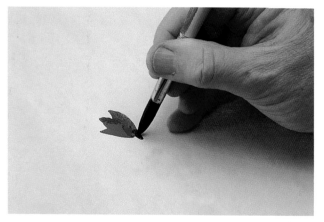

Using the same press/release technique, I'm going to paint a maple leaf.

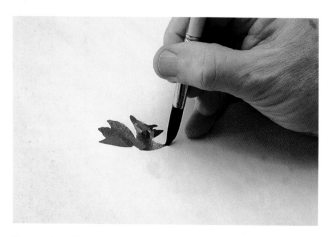

Notice how I can paint a point of the maple leaf simply by releasing the pressure on the brush.

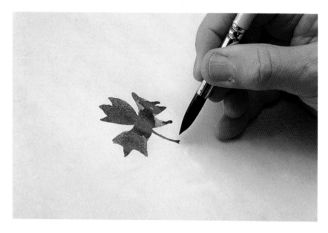

The brushes are designed to come to a fine point, exactly what we need when doing detail work, such as this leaf stem.

Pine Cone

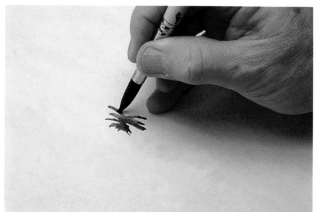

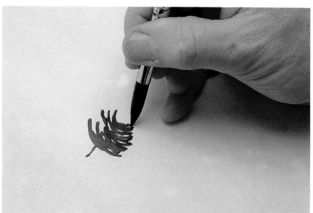

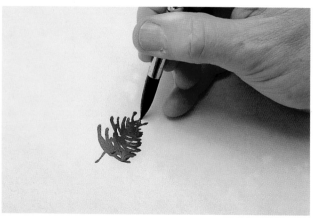

I think these pictures illustrate the method. Have some fun with it. Lighten up! You'll find that by working on newsprint you can have a bit of fun. Painting on the more expensive paper can be intimidating to the beginner; that's why we're going to stick with newsprint for now.

Square Brush Exercises

Hopefully you've used up all your paint in creating objects with the round-tipped brush. Go mix some more, because now we're going to experiment with a ½-inch (12mm) square-tipped brush. Square brushes are used to paint everything from bricks to barn doors—anything that has a straight edge. The square brush produces all kinds of interesting shapes.

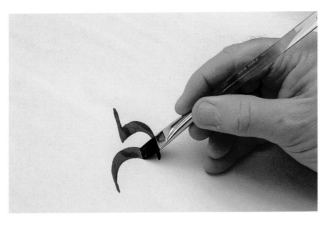

By turning the brush on its side you can vary the width of your line.

. . . dotted lines . . .

Practice making these shapes.

. . . Any rectangular shape.

Boards, bricks . . .

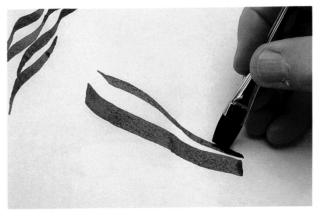

Here I'm drawing a narrow tree trunk; compare it to the fat one beside it. See how rotating the brush slightly in your hand produces an entirely different effect? The technique is subtle; the effect is blatant.

Sho-Card Brush Exercises

The Sho-Card lettering brush was designed for lettering, not painting. It is sometimes referred to as a single-stroke lettering brush. I use it a lot because this was the brush that kept food on my table during my years as a sign painter. Now, you're probably wondering what a lettering brush has to do with watercolor painting. I assure you, I'm not trying to teach you calligraphy. I'm trying to teach you that learning to paint is much like learning to print all over again.

The best way to discover the power of this brush is to practice with it against the stock listings from your newspaper. The tight symmetry found on these pages will steady your hand.

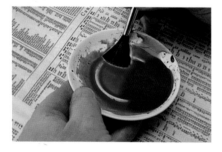

In loading up the Sho-Card brush, you will notice that it holds more paint than its ½-inch (12mm) square-tipped sibling.

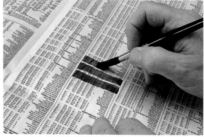

PARALLEL LINES
Paint a series of lines, side by side. Don't worry if your lines are a bit uneven. They're bound to be. This is why we're practicing!

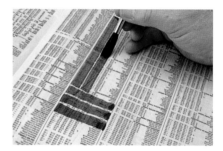

When you come to "the end of the line," so to speak, you want to make a clean break. Release pressure and gingerly raise the brush.

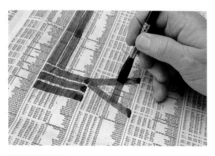

ANGLED LINES
Try painting the letter A or any figure composed of angled lines.

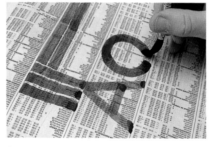

CURVED LINES
This is a tough one. It looks easy but it's not. This is a good exercise to practice curves and to see what the Sho-Card brush can do.

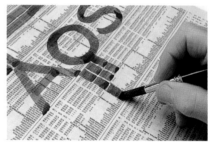

BLOCKS
After you have completed a number of these strokes, try to paint a windowpane, chimney, board fence, bricks or whatever.

Rigger Brush Exercises

Notice the long hairs on a rigger. They hold a lot of paint, so you can cover long stretches. This is the brush you'll be using for long, thin objects, such as tall grass. Other objects that you may want to paint, such as wire fences or saplings, require the detail that only the rigger brush affords. Some veteran painters talk about "rigger remorse." I'm not sure whether they are lamenting the fact that they didn't use a rigger when they should have, or whether they screw up a lot with it. Personally, I love this little sweetheart of a brush. I once had a young teenaged student who was experimenting with a rigger. He was competent right off the bat. "Hey, man," he exclaimed. "I'm doin' grass!" His eyes sparkled in awe at his own talent, not with the funny stuff.

In order to get comfortable with the rigger, look around where you are sitting right now and attempt to draw objects that call for the kind of detail we are talking about. It could be an electrical cord, your dog's hair or the leaves on a fern. Just remember: If you want pinpoint accuracy, the rigger brush is the one.

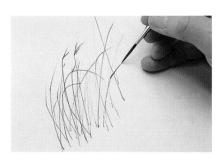

THE RIGGER BRUSH
When using this brush, try to think of how many subjects you could paint: grass, twigs, saplings, hair, wire and so on. I have suggested a few. Try to come up with some new ones.

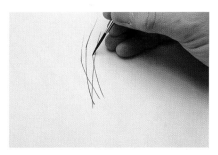

The rigger is great for painting grass. With a series of short, sharp upward strokes, I have painted the stalks.

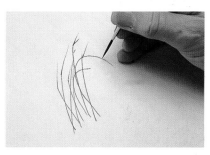

With a series of downward strokes, I've hooked the grass, and with these strokes, it comes to life.

Need more detail?

Wire fence.

Sapling.

Conclusion

Each of the four brushes mentioned in this chapter—round-tipped, square-tipped, Sho-Card and rigger—can be used to paint a family of related objects. You are limited only by your imagination. You may be interested to know that these brushes are all you will ever need, with a few exceptions. Just remember: It's not the brush that does it, it's your control of the brush.

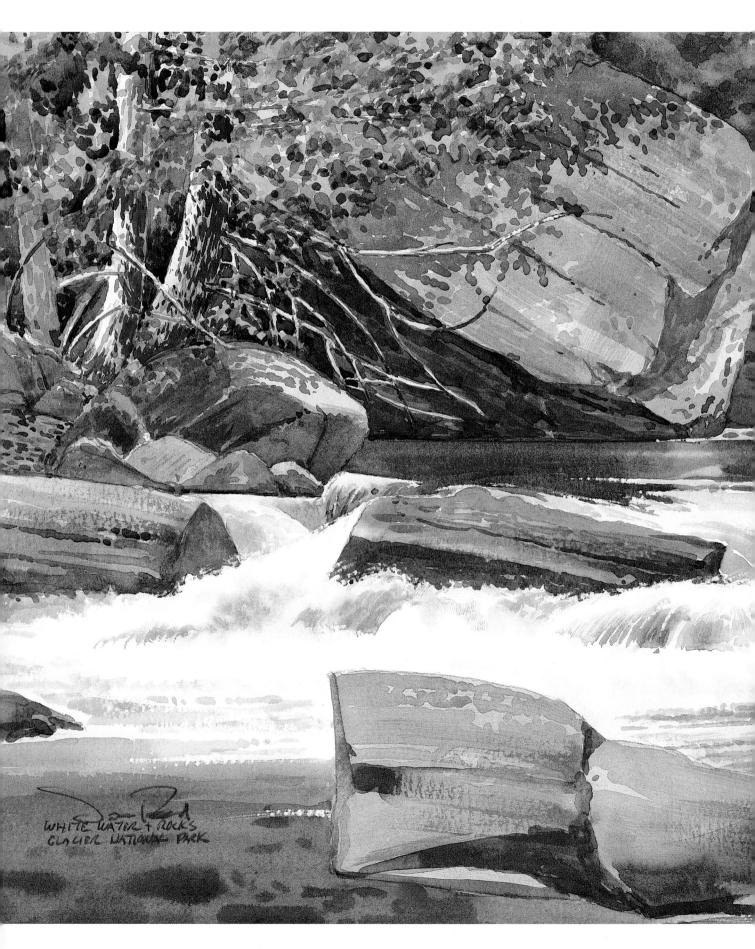

WHITE WATER + ROCKS
GLACIER NATIONAL PARK

FOUR BASIC TECHNIQUES

The time has come to get our brushes wet. We'll be looking at four basic techniques in this chapter: flat wash, graded wash, wet-in-wet and dry-brush. These techniques, once learned, will enable you to paint a wide variety of objects.

White Water and Rocks
Glacier National Park, Montana, U.S.A.
14″×20″ (36cm×51cm)
Watercolor painted plein air on Winsor & Newton 260-lb.
(550g/m²) watercolor paper
Collection of Mrs. Maggie Reid
Brampton, Ontario, Canada

Flat Wash Exercises

A flat wash is simply one color painted over part or all of the paper. While it is one of the most basic techniques used in watercolor painting and seems easy enough, it's really quite tricky to lay an even flat wash. Gravity must be on your side. Since you want the paint to flow gently in the direction toward which you are painting, it is crucial that you tilt your Coroplast work surface to about a 15° angle.

House and Hills

Tape a 5½" × 7½" (14cm × 19cm) piece of 300-lb. (640g/m²) rough-surfaced paper to your Coroplast, and make sure the work surface is tilted gently toward you. This slight angle will draw the paint downward. Draw a pencil sketch of house and landscape like the one below, and then just follow the step-by-step instructions.

Because we use the glazing technique, painting color on top of color after each wash is completely dry, we will end up with a picture that has three values, even though we will use only one color. Since this is your first attempt at a flat wash, don't get too discouraged if you blow it. Tape several pieces of paper to your Coroplast and try the exercise again and again until you succeed. You'll get it sooner or later.

First, use a mixing bowl and a 1-inch (25mm) square brush, mix a medium value of Ultramarine Blue. (*Value*, which we will discuss in the next chapter, is the strength or intensity of a color.) Always mix more than you think you'll need; it's very frustrating to run out of paint halfway through a wash.

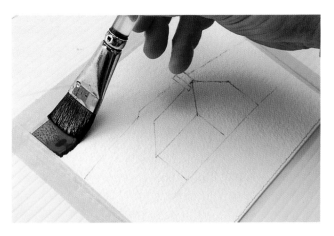

Step 1: The Flat Wash
With the board at an angle, load your 1-inch (25mm) square brush and drag it across the paper beginning at the upper left-hand corner. Don't lift your brush until you've run off the other side of the paper, and don't go over it twice.

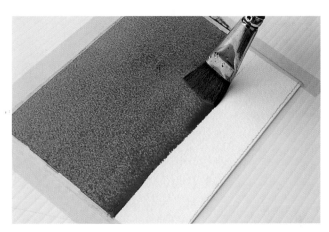

Step 2: Overlapping
Thanks to gravity, excess paint collects along the bottom edge of the line you just painted. Remove the excess by overlapping the bottom edge of the first pass with the top edge of the second, and so on till you've finished the entire paper. Reload your brush after each pass. When you have painted the whole area, wipe your brush with a clean tissue, then run it along the bottom edge if there is a bead of paint there. Now, lay your painting flat and let it dry, either naturally or using a blow-dryer. If you use a blow-dryer, hold it about 18" (46cm) away from the paper so the force of the air won't disturb your wash.

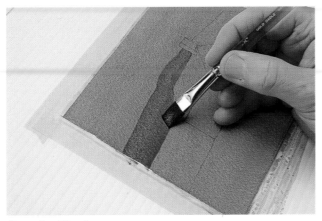

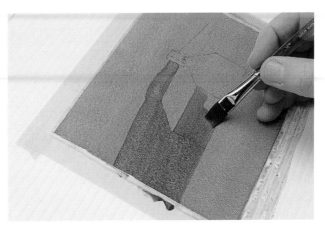

Step 3: Glazing

After the wash is dry, load your ½-inch (12mm) square brush with the same value of Ultramarine Blue and do another flat wash, using the same overlap technique as before, and paint in the mid- dle area, with the exception of the house's exposed roof. Since it is going on top of an existing flat wash, we call it a *glaze*—a coat of transparent paint that modifies the underlying tone.

Step 4: The House

Again, using your ½-inch (12mm) square brush, apply a flat wash to the barn, remembering not to paint the sunward roof and following the lines of the pencil drawing precisely. Don't be afraid to rotate the picture this way or that in order to make the act of painting more comfortable. You'll notice that by glazing over an existing wash we have increased the color's value—without changing the value of our mix. Glazing causes increased value.

Step 5: Finishing Up

Use your Sho-Card brush to wash in the chimney. It's much easier to tickle in small square objects with the Sho-Card than any other brush. Notice how I rotate the paper to get better access to the area I want to work on.

Boat in Water

For our second flat wash exercise, we are not going to cover the entire piece of paper. Just as before, tape your 5½" × 7½" (14cm × 19cm) piece of 300-lb. (640g/m²) rough-surfaced paper to your Coroplast. Make sure the work surface is tilted toward you. Using an HB pencil, gently draw the scene based on the final picture on the facing page.

Step 1: The Jetty

Make a light-value mix of Ultramarine Blue. Turn the work surface upside down and, using your Sho-Card brush, stroke in the dock, the supports and the building.

Palette:
Ultramarine Blue

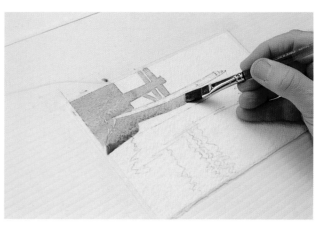

Step 2: The Boat

Using the same mix as before, load a larger square brush and paint in the boat. The square brush relates best to the shape of this boat. Always pick the brush that fits the shape. This will make the technique easier to execute—and that's the goal here. Please do not paint over the bow rope. This is a picky point, but we can engender in our painting a sense of realism if we pay close attention to a small detail such as this.

Step 3: The Reflection

Using the same brush and mix from the previous step, drop in a flat wash for the boat's reflection. Remember to overlap your strokes.

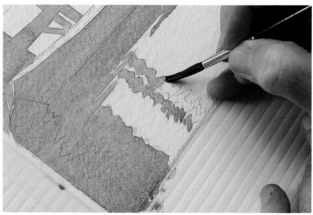

Step 4: Jetty Reflections

Using your Sho-Card brush again, but sticking with the same mix, drop in the reflections of the jetty and the building. Don't be afraid to let your hand waver a little here. This is easier for seniors such as myself!

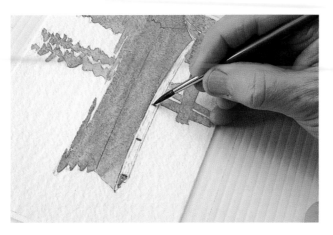
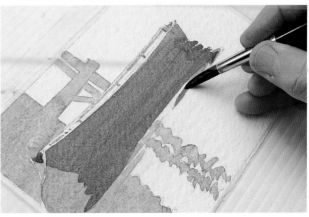

Step 5: Boat Rail Detail

Using a no. 8 pointed round brush, drop in the gunwale detail. Try to keep it simple, as I've done.

Step 6: Glazing

Using a no. 10 pointed brush, drop in another flat wash on the boat and her reflection. This is also called a glaze.

Step 7: Scoring

Anytime you scratch good paper with wet watercolor paint, you create a channel; the paint then runs into the channel. When it dries, it dries darker. It's a good way to add texture to objects. So take an old paring knife and gently, but with authority, drag the tip along this section of the bow. This creates an effect of thin lines resembling the boards on the side of the boat.

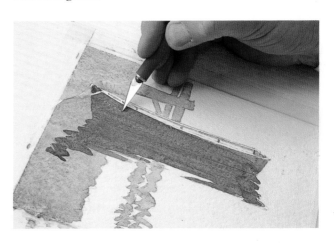

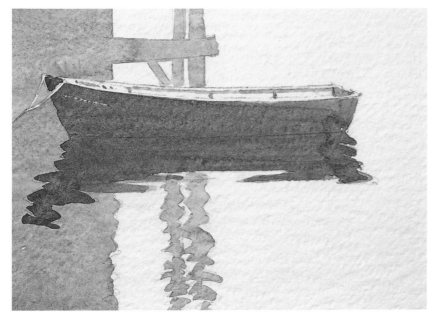

Boat in Water
5½" × 7½" (14cm × 19cm)

Here we have the completed picture. Notice that by leaving a large area of the paper plain white, a sense of mist or fog is evoked—and you didn't even have to do anything! This is an important point to remember concerning composition: What you leave out can be as dramatic as what you put in. Less really is more, in this sense.

Palette:
Ultramarine Blue
Burnt Sienna

House in Winter

For our final exercise in the flat wash, I'm going to make things interesting by using two colors: Ultramarine Blue and Burnt Sienna. This is a good exercise because it utilizes a number of different brushes and provides an opportunity to experiment with mixing two colors.

Though this is our last flat wash exercise, don't think that you've seen the last of them! Flat washes will be an essential element of many of the exercises from here on in. Flat washes are to watercolor painting what nails are to a carpenter.

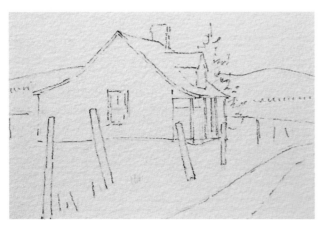

Step 1: Pencil Sketch
Tape a 5½" × 7½" (14cm × 19cm) piece of rough-surfaced 300-lb. (640g/m²) paper to your Coroplast, and pencil in this simple drawing.

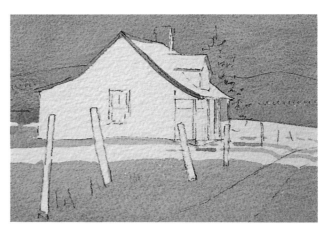

Step 2: Flat Wash
Mix a medium value of Ultramarine Blue and apply a flat wash to the sky, the foreground and sections on and around the house, as shown above. Remember to befriend gravity by tilting your work surface. Also remember to slightly overlap the bottom edge of your previous stroke in order to pick up the excess paint. Be careful not to paint over the fence posts.

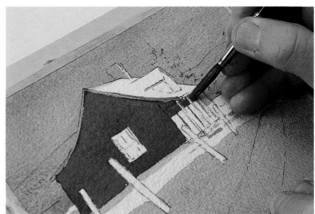

Step 3: The House
In a separate dish, make a mix of Burnt Sienna to a medium-dark value. Using your Sho-Card brush, paint a flat wash over the portions of the house shown above, remembering to overlap your strokes. Apply a small band of color underneath the overhang. This will serve as a shadow. We're going to leave the space beneath this shadow white in order to suggest that it is in direct sunlight. The same applies to the sunward portion of the roof.

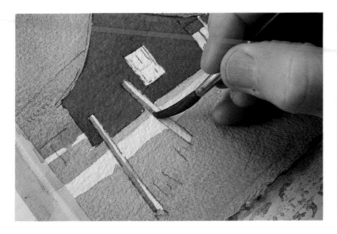

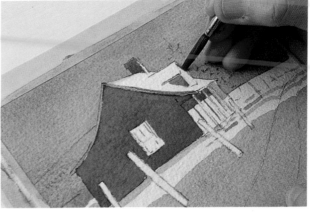

Step 4: The Fence Posts

Using the same mix and brush, drop in a strip of color down the length of the posts. Again, leaving half the post white suggests that light is striking them.

Step 5: Dormer Detail

Rotating your Sho-Card brush so that the tip is lengthwise, apply a mini flat wash, if you will, to the dormer window wall and eaves.

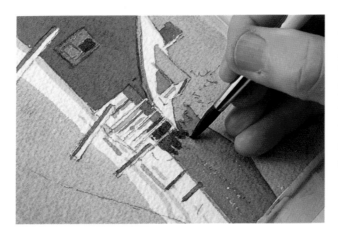

Step 6: Glazing the Background Hills

You'll notice the hills in the background are now darker. I won't bother showing you how I did it because you already know at this point. Here's how to do it: After your picture has dried, load your ½-inch (12mm) square brush with a medium-value mix of Ultramarine Blue and stroke in that distant hill behind the house. Let the picture dry completely, or get your blow-dryer going.

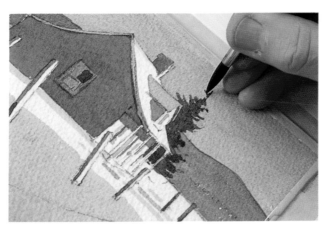

Step 7: The Pine Tree

Using a new dish, mix Burnt Sienna and Ultramarine Blue to a fairly strong value. You should end up with a dull brown-gray color. You'll notice there's a very tricky square area of the tree as seen through the posts of the veranda. No problem: Square objects call for square brushes. So, use your Sho-Card brush for this tricky area and, with the same mix, for the detail on the main window. Use your no. 8 pointed brush to complete the rest of the pine tree. You paid good money for your brushes, so make them work; utilize the brush's pointy tip to achieve real-looking details. Don't be afraid to move your picture around to get it in a position that's comfortable for you.

Step 8: Background Stand of Trees

Take the same mix with which you painted the pine tree and reduce its value by adding some water. Using your no. 8 pointed brush, paint in the distant stand of trees on each side of the house, the penciled outlines of which should be visible. Work the tip of the brush in order to render the fine treetop detail.

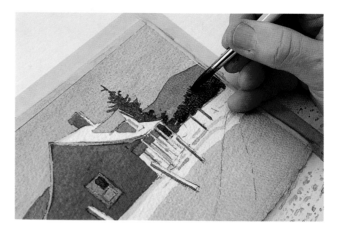

Step 9: Tire Tracks

We're going to need the no. 8 pointed brush to do these tire tracks so clean it thoroughly in water. Make a mix of Ultramarine Blue to a medium-dark value. Painting in each track calls for a very graceful stroke, beginning with quite a bit of pressure and gradually tapering off to just a whisper. This should bring back memories from the newsprint exercises. By all means, practice this stroke on some scrap paper if you're feeling a little rusty. Feel free to rotate the picture to a position that's comfortable for you.

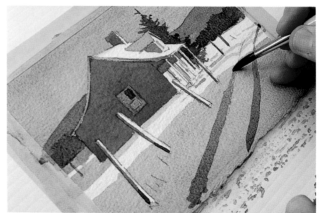

Step 10: The Grass

To add the finishing touch to this picture we will rely on our trusty little friend, the rigger brush. With short, sharp strokes tickle in the grass. I use the term *tickle* because that's what it feels like when using this brush. I begin at the bottom of the grass and "flick" upward.

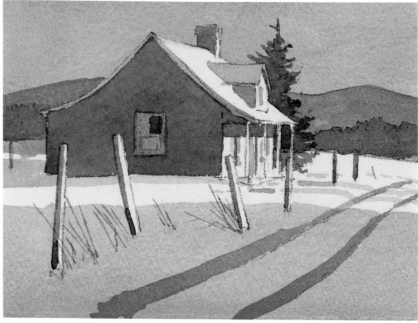

House in Winter
5⅕" × 7½" (14cm × 19cm)

Graded Wash Exercise

It's quite simple: A graded wash is a field of color, painted over all or part of the paper, that gradually fades away or gets stronger depending on how you look at it. A graded wash is done just like the flat wash with the work surface tilted and each stroke overlapping the wet bottom edge of the previous stroke. But here's the difference: You start with clear water and gradually add more and more color to your mixing bowl, making each stroke darker. (Or, conversely, you start with pigment and gradually add clean water.)

Barn

This will be an extreme example of the graded wash. You see in the picture below that I've drawn a very simple barn. I admit it's a little cockeyed; this isn't a course in drawing. I don't have trouble drawing things, but you might not be as comfortable. Therefore, I've tried to select subjects that are relatively simple, not in all cases but in most. The last thing I want to do is intimidate you.

So, here we have this barn sitting dead center in a field. I'm told you shouldn't put buildings in the center, but for the sake of this exercise, it stays. We'll talk about composition in the final chapter.

We begin as always by taping a 5½″ × 7½″ (14cm × 19cm) piece of 300-lb. (640g/m²) rough-surfaced paper to our Coroplast and then penciling in the drawing below.

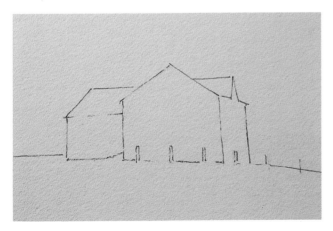

Step 1: Pencil Sketch

Palette:
Ultramarine Blue

Step 2: The First Stroke
First you need to do a flat wash of clean water. Flip the Coroplast upside down and tilt it slightly toward you. Load your 1-inch (25mm) square brush with clean water and with a long, steady brushstroke drag it from left to right across the horizon line. Just make one pass.

Step 3: The Second Stroke
Make a pale mix of Ultramarine Blue. Load your brush with it and stroke it in just below the area of the previous stroke, remembering to overlap the bottom edge of the first water wash.

Step 4: The Third Stroke
Strengthen your mix by adding in more Ultramarine Blue from your tube. Just as before, drop in this third stroke over the bottom wet edge of the previous stroke.

Step 5: The Last Stroke

Finally, pump the value of the mix to near maximum, then stroke in the final pass. Lay the Coroplast flat and let your graded wash dry. After it has dried, flip your Coroplast around and have a look. What you'll see is a sky, a very ominous-looking sky, I might add.

Step 6: Flat Wash

Still using the same brush and high-value mix, paint in the barn and foreground. Let your work dry.

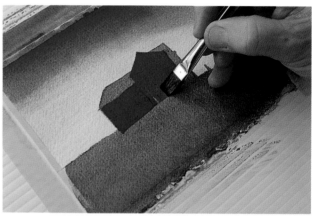

Step 7: Glazing

Using your ½-inch (12mm) square brush and the same mix, apply another cover of paint over the barn. Do not paint over the sunward roof and wall.

Step 8: Fence Posts

Do not paint where you'll want to place the fence posts that are in front of the barn. You'll paint those posts by not painting them, so to speak. Merely rest the side of your brush on the paper for a fraction of a second.

In some situations, one must learn to paint quickly.... There's an old story of two painters who were painting a scene on the edge of a duck pond. One painter was an old pro, the other her student. After a few hours, the pro was finished with her picture. Turning to have a look at the student's progress, she saw that all he had managed to paint was the feet of one duck. When she asked him what his problem was, he replied, "Gosh, you gotta be fast to paint ducks!"

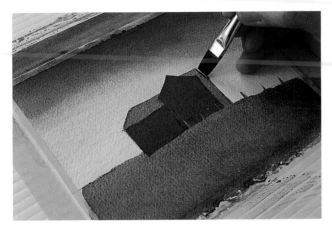

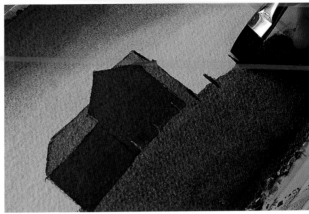

Step 9: Dormer Detail

By utilizing the side edge of your ½-inch (12mm) square brush, drop in a shadow on the eaves of the dormer window.

Step 10: Fence Posts Again

Go over the remaining fence posts once again to increase their value.

Step 11: Scoring

You know by now that scratching a dull edge into wet paint can create some pretty dramatic effects. To suggest barn boards, I've used the scoring end of my ½-inch (12mm) square brush to score the barn with straight lines. But don't score in all the boards; less is more.

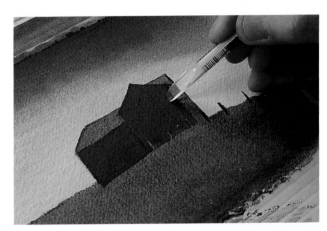

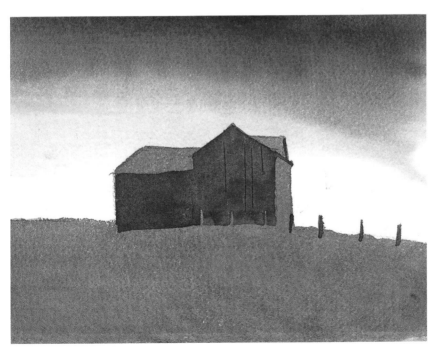

Barn
5½″×7½″ (14cm×19cm)

Wet-in-Wet Exercises

The wet-in-wet technique means precisely what it says: putting wet paint on wet paper. The thickness of the paint and the wetness of the paper will determine the level of control you have over what you're painting. In any wet-in-wet painting, it's a good idea to use rough-surfaced paper because the paint settles better. The trick is to make the color dark enough and avoid overwetting the paper. You will also discover that you have to move swiftly before the first wash dries. Timing is crucial when executing a wet-in-wet.

Palette:
Burnt Sienna
Ultramarine Blue

Two Pines

In this exercise, we're going to paint a very simple scene of two pines in grass. As usual, tape a 5½" × 7½" (14cm × 19cm) piece of rough-surfaced 300-lb. (640g/m²) paper to your Coroplast. I haven't sketched anything onto the paper beforehand because this is old hat to me, but I think you should. It will help guide you. Base your simple drawing on the completed picture on the facing page.

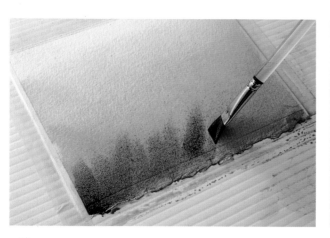

Step 1: Grass
Cover the entire paper with a graded wash of Burnt Sienna. While this is still wet, stroke in a mixture of Burnt Sienna and Ultramarine Blue along the bottom with random upward strokes using a ½-inch (12mm) square brush. This gives us a brown-gray grass. In this case we have a brown of medium value.

Step 2: Tree
While the graded wash and the wet-in-wet grass are still wet—and you have to be fairly quick here—take your ½-inch (12mm) square tip and paint the pine tree in.

Step 3: Another Tree
With a slightly lighter value of the Burnt Sienna and Ultramarine Blue and with a no. 8 round brush, I'm about to paint in a smaller pine tree in the distance.

Step 4: Reinforcement

With a heavier pigment, I'm adding a little more detail to the large pine. I call it "spidering" the edges. It creates the illusion of the fir tree as seen from a distance.

Step 5: Scoring

I'm taking the blunt edge of the 1-inch (25mm) square brush and scoring or scratching in the some of the grass while it's still wet. You can use your dull-as-dishwater paring knife here, if you want.

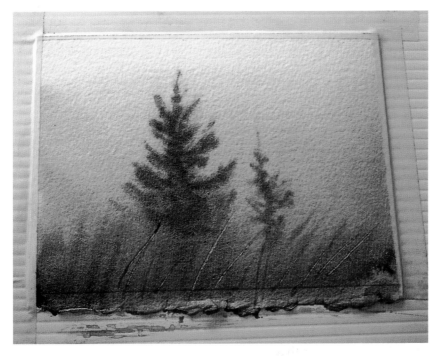

Two Pines
5½″ × 7½″ (14cm × 19cm)

Inspiration and Perspiration

You can see that when using the wet-in-wet technique, you have to move fast. It's fairly simple, but simple doesn't mean easy. You have to work at it. Practicing to paint this picture will teach you how important time is to achieving the desired effect. Time really is the essential factor when doing a wet-in-wet. Just remember this: Success in painting breaks down to about 10 percent inspiration and 90 percent perspiration. If you didn't get it right the first time, do it again, and again, and again. . . .

Step 1: Sketch of Bulrushes

This is a very simple sketch of a bulrush with just a few leaves in the background. As everyone knows, when the bulrush comes to maturity, it "explodes" into thousands of spores.

Bulrush

We are going to employ just two colors to paint a very simple but attractive picture of a bulrush in this exercise. As before, tape a 5½" × 7½" (14cm × 19cm) piece of rough-surfaced 300-lb. (640g/m²) paper to your Coroplast.

Palette:
Burnt Sienna
Ultramarine Blue

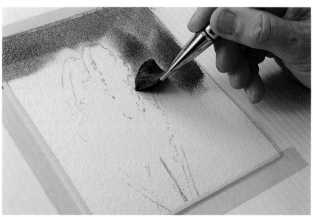

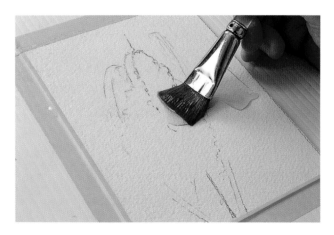

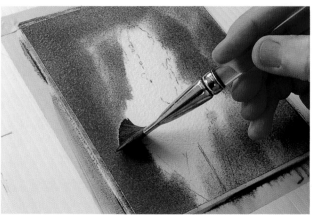

Step 2: Wetting the Paper

Saturate the entire sketch with water using either your 1-inch (25mm) flat brush or your hake brush, it doesn't really matter. Using a tissue, lift away any excess beads of water that might be hanging around the edges. If you don't, these "renegade" beads can accidentally reenter your painting at a later stage and cause what's called a *back run*. This is a very ugly occurrence and the bane of all watercolor painters.

Step 3: Surrounding Area

Avoiding the bulrush sketch, load your 1-inch (25mm) square brush and paint the surrounding area with a medium value of Ultramarine Blue. Notice how I'm painting the bulrush by not painting it, if you'll forgive the contradiction. So here, we are putting wet paint on wet paper.

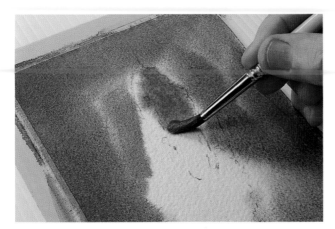

Step 4: Paint the Pod
Remember, you're working on wet paper. You have to be quick. Take your ½-inch (12mm) round brush and load it with a high-value, thick mix of Burnt Sienna and paint in the head of the bulrush.

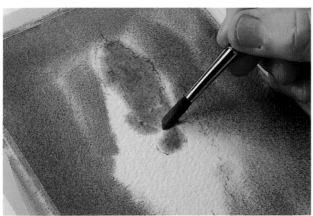

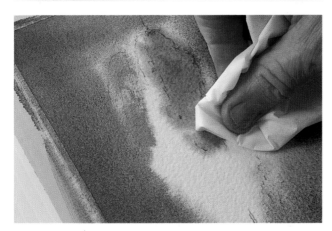

Step 5: Lifting
Take a tissue and remove excess moisture from the rush's pod, because we are about to paint over it; that is, we are about to do another wet-in-wet.

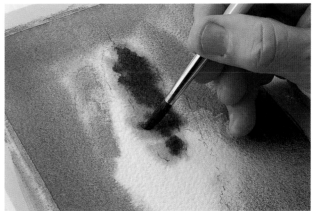

Step 6: Painting the Focal Point
Taking the same ½-inch (12mm) round brush that you've been using, mix Ultramarine Blue and Burnt Sienna into a dark brown. Make this mix quite thick because you'll want it to stabilize shortly after you apply it to the paper.

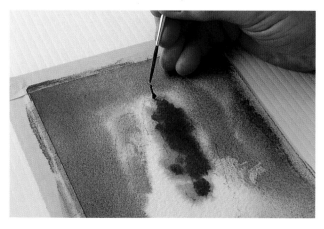 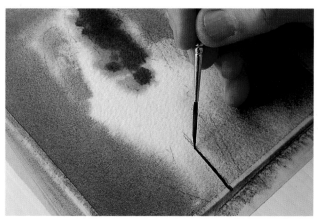

Step 7: Rigger Detail

Using a darker value of brown, put a little tip on top of the pod and then brush in the stem and the leaves, remembering that as you move into the white area (of exploding spores) you should add some water to the color to dilute it. In effect, it's a graded wash. Use a tissue to lift off some of the excess water if some gets away from you.

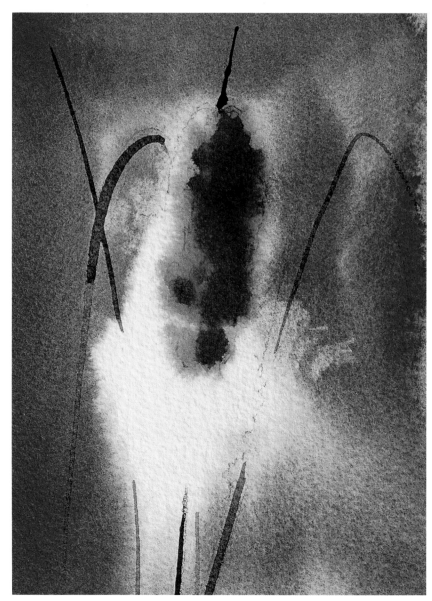

Bulrush
5½″ × 7½″ (14cm × 19cm)

Winter River

For our third attempt at a wet-in-wet, we'll take a different subject from a different season: a wintertime river. This will be quite a challenging picture for a novice, but I think it's worth taking a chance on because the picture is very rewarding when you succeed.

Tape a 5½" × 7½" (14cm × 19cm) piece of 300-lb. (640g/m²) rough-surfaced paper to your Coroplast. The little pits in the rough-surfaced paper hold paint and water better than smooth paper does. Also, we'll be using quite a bit of paint,

Palette:
Ultramarine Blue
Burnt Sienna

but this heavy grade of paper will not buckle. Again, I haven't sketched in the objects to be painted, but I would advise that you take a minute to do so just so that you see where everything's going to go. Base your sketch on the completed picture on page 47.

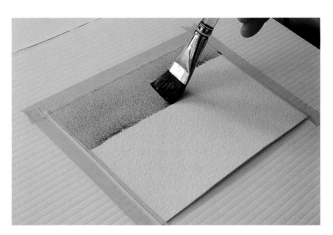

Step 1: Flat Wash

Mix some Burnt Sienna and Ultramarine Blue to a warm gray color. With the Coroplast lying flat, apply the wash to the top third of the paper's surface and then quickly dip your brush in some clean water and pull it along the bottom of your wash to blur up the transition into the white area. This transition zone will serve as the horizon in this picture. Next, clean your brush off with water and wash the remaining white area with your wet, clean brush. It has to be wet because we'll be working in there in a few moments.

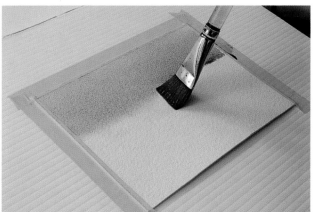

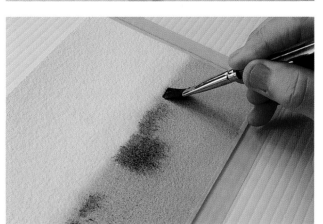

Step 2: Wet-in-Wet

To paint the obscure trees in the distance, mix Burnt Sienna and Ultramarine Blue to a medium deep brown. Take your ½-inch (12mm) square brush and stroke in the new color briskly. Don't be afraid; just use brisk, positive strokes.

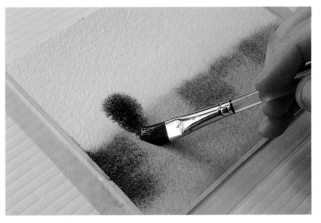

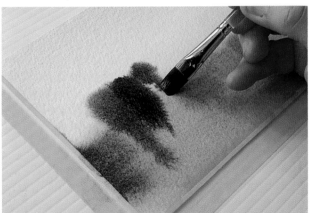

Step 3: Foreground

Time to brush in the foreground trees, and that means time for another color. Mix an even more intense value of the Burnt Sienna and Ultramarine Blue, giving you a very deep brown. Remember that this all has to be done on wet paper. If your paper has dried up at this point, wet it again with a clean water glaze. Do the trees one at a time, and overlap them. Everyone knows what a cedar tree looks like: fat at the bottom, tapering to a point up top. Get creative. When you finish the trees, plug in the blow-dryer and give your work a good going-over until it's completely dry.

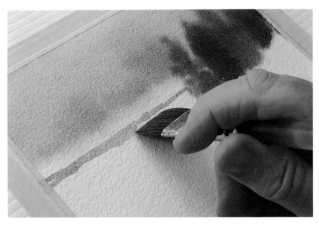

Step 4: The River

We're going to want gravity on our side for this step so tilt the work surface to about 15°. Using the same two paints that we've used so far, mix a value resembling the one we used for the sky, maybe a little darker. Then, with the white area still wet, hold your 1-inch (25mm) square brush lengthwise, stroke in the distant lake and then slip in the fluid, weaving lines that will become the river.

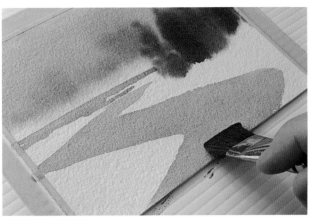

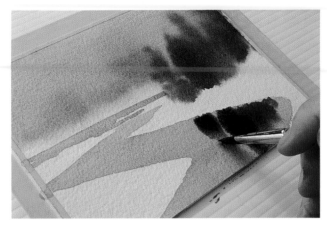

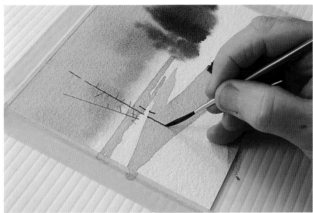

Step 5: Reflections

Reflections are always darker than the objects reflected. For this reason, make a dark, thick mix of your two base colors. Now load your brush and, with the Coroplast still tilted, paint in the reflection. The river we painted in the previous step should still be wet, so this is another wet-in-wet. Watch gravity go to work. It takes time and practice to paint a realistic reflection. After a rainy day, pause before the puddles on your porch or street and look closely at how the reflections appear. Studying nature will help you to paint nature. It just takes an appreciative eye. You'll get it if you practice. Never stop looking at these small details in everyday life.

Step 6: Dead Trees

It's strange how dead trees add life to a picture, but they do. Load your rigger brush with the same mix used in the previous step and paint in the slender trunks as shown. If you're a little queasy about using your rigger—or any other brush—go back to the newsprint and practice painting a few dead trees.

We're done. Here you have a simple yet attractive picture using just two colors and simple value combinations. This isn't rocket science, folks. If you weren't quite successful the first time around, go back and do it again. The know-how you'll derive from executing this simple painting will be put to use in the next exercise.

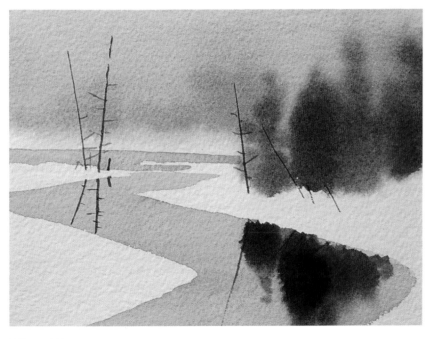

Winter River
5½" × 7½" (14cm × 19cm)

Dusk

You should be getting the hang of the wet-in-wet technique by now. For our last exercise we'll paint a scene at dusk. Again, we'll use only two colors. Picture elements will include clouds, a lake and a foreground shoreline. The soft and varied hues of dusk colors demand the wet-in-wet technique. We want to project a feeling of seamlessness where colors flow into one another.

Palette:
Burnt Sienna
Ultramarine Blue

The first step, as usual, is to tape your 5½" × 7½" (14cm × 19cm) 300-lb. (640g/m²) rough-surfaced paper to the Coroplast and sketch the basic scene based on the completed picture on page 50.

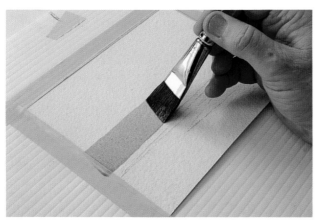

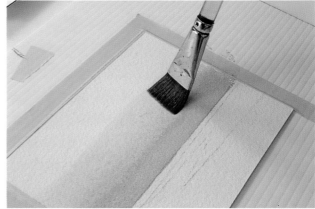

Step 1: Flat Wash

Mix some Burnt Sienna to a dark value and draw the horizon line using your 1-inch (25mm) square brush. Before you stroke in the second pass, add some water so that it gradually becomes lighter. Continue on until you've wetted the entire top portion of the picture.

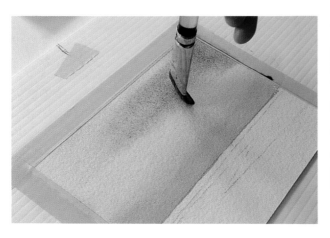

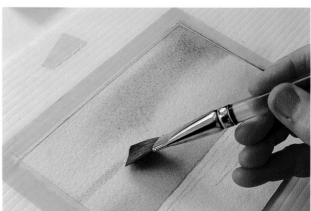

Step 2: Wash of Clouds

Using the same brush, mix in some Ultramarine Blue with the Burnt Sienna to give you a fairly light, warm gray and wash in the distant, high clouds. Special note: With all wet-in-wets, colors grow fainter after they've dried. The reason is simple: Putting wet paint on a wet area dilutes the color values. Therefore, since wet-in-wet paint dries lighter, you must use a stronger value of the one you want to see in the finished picture. So, make this first wash of clouds a little stronger than you think it should be.

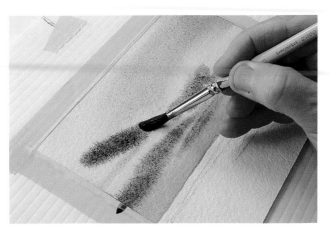

Step 3: More Clouds

Using a deeper value of our mix, grab your no. 8 pointed brush and add a few more clouds. Remember to allow some space for your objects to expand, as they will do whenever you're painting wet-in-wets. It's tricky to gauge just how much they will spread, but it's not that tough once you get the idea.

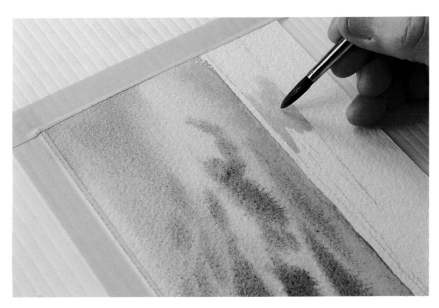

Step 4: Graded Wash

This is the water area. Take your pointed brush and do a graded wash with Burnt Sienna. Begin with clean water on the side closest to the light source, gradually adding in the Burnt Sienna.

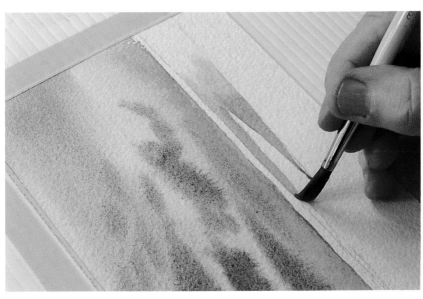

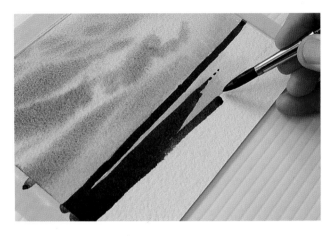

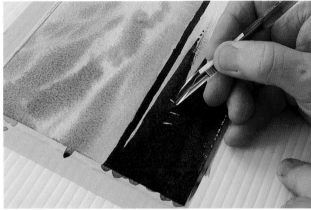

Step 5: Shoreline

After everything is quite dry, take your pointed brush again and mix a very dark value of Burnt Sienna and Ultramarine Blue and, with brisk strokes, brush in the shoreline.

Step 6: Scoring

Use the wedged end of your brush (if it is so equipped) or your dull paring knife to scratch in some vegetation.

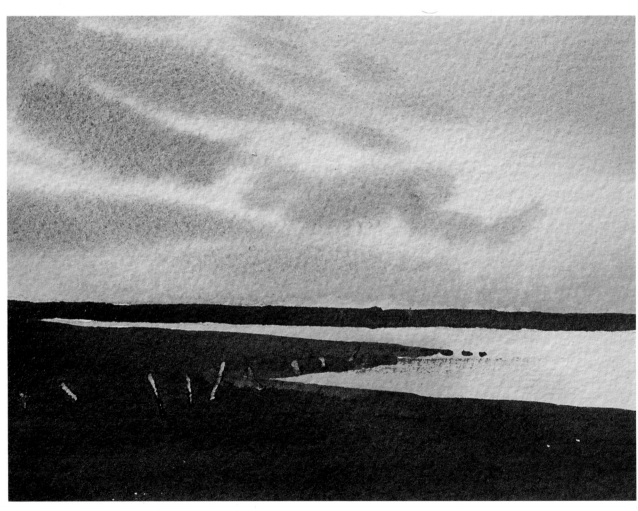

Dusk
5½″ × 7½″ (14cm × 19cm)

Dry-brush Exercise

You have now arrived at a point where you can pull off flat and graded washes and have nailed down the basic wet-in-wet technique. This next exercise will incorporate those three techniques and add one more: the dry-brush. This technique involves painting with a brush that is almost empty; as you drag the brush across the paper, it runs out of paint and creates a mottled effect.

Palette:
Burnt Sienna
Ultramarine Blue

Dead Tree and Lake

This exercise will test your ability to paint around things. View the sequence now and do your sketch on a 5½″ × 7½″ (14cm × 19cm) piece of 300-lb. (640g/m²) rough-surfaced paper.

Step 1: Graded Washes

There are two graded washes in this picture. The first is that clump of color in the bottom right-hand corner. It doesn't look like much now, but it will end up resembling driftwood. Make a light brown mixture of Burnt Sienna and Ultramarine Blue and wash in the driftwood, steering lighter values to the left.

Now, adding a little Burnt Sienna to your existing mix, do the graded wash on the tree. Add water to the left side of the tree; you want this to be lighter because it's facing the light.

Use your no. 8 round brush to paint in a little bit of shadow on the dead branches.

Step 2: Wet-in-Wet Clouds

Flood the area to the left of the tree with clean water (notice that I've flipped my paper upside down here). Mix your two base colors into a blue-gray. Load your no. 8 round brush and apply it in the manner shown above. Paint around the tree's branches. Try as best you can to prevent your cloud shapes from running into one another; otherwise your whole sky will become black.

Now you have to give the lake a bit of detail. Do a graded wash of Ultramarine Blue, medium value, just as you see above, remembering to paint around the branches.

Step 3: Background Trees

Flip the paper right side up again. Load your no. 8 round brush with a dark mix of Burnt Sienna and Ultramarine Blue and fill in the area shown. To paint the tops of the trees, lift out some of the pigment with a tissue.

Step 4: Drybrushing

Load your ½-inch (12mm) square brush with a medium value of Ultramarine Blue. Now grab a tissue and remove most of the paint from your brush. Be careful not to remove all the paint from the brush. You can see I've also done a graded wash on the background mountain.

Step 5: Drybrushing

Drag your dry brush over the water horizontally to create a sparkling effect. Don't squish your brush into the paper. If you have to squish it to get the paint out, you've removed too much. Continue drybrushing to the bottom of the paper. The horizontal lines indicate the shadows of the clouds above.

Step 6: More Drybrushing

Splay the tip of your pointed brush with some thick brown paint and then remove most of it with a tissue. Add shadows to the tree branches and texture to the trunk and driftwood at the base.

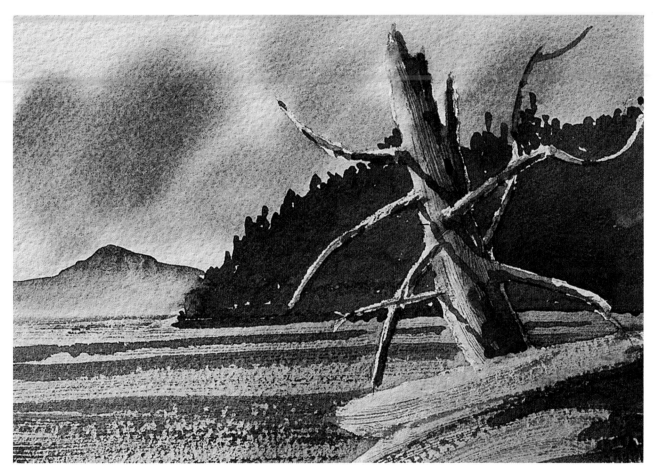

Dead Tree and Lake
5½″×7½″ (14cm×19cm)

Congratulations!

You have now executed the four basic techniques of watercolor painting. I suggest you review all the lessons in this chapter to keep all four techniques fresh in your mind.

Remember

If you're having difficulty with any of the techniques we've learned so far, go back to the newsprint and practice. If you're hesitating or if one part of the exercise is just too intimidating, don't worry. Master the technique on newsprint, then return to your painting.

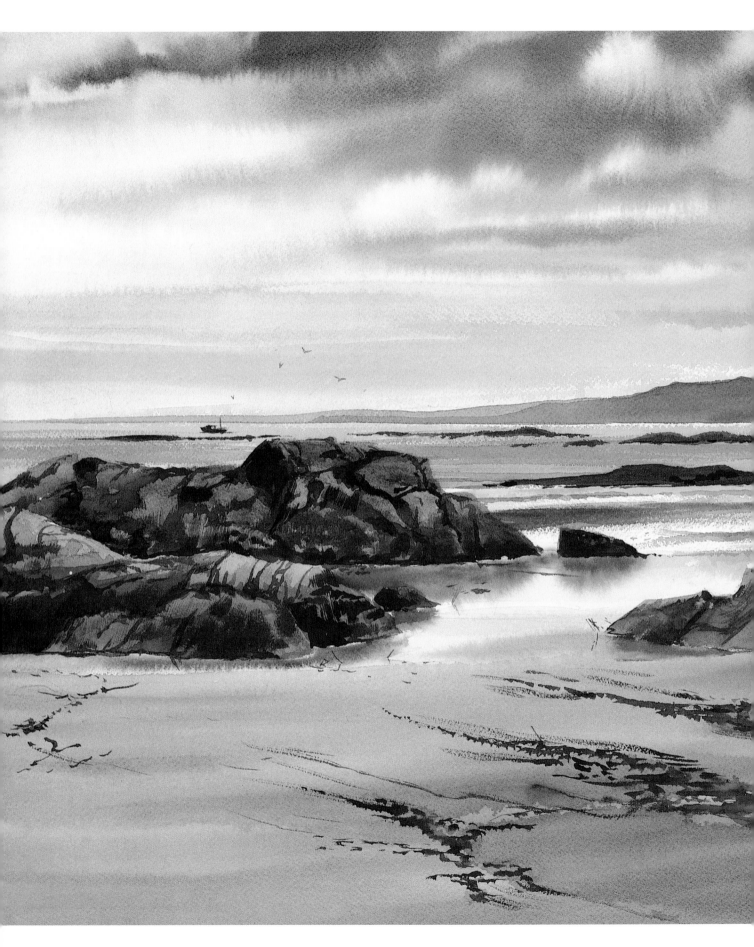

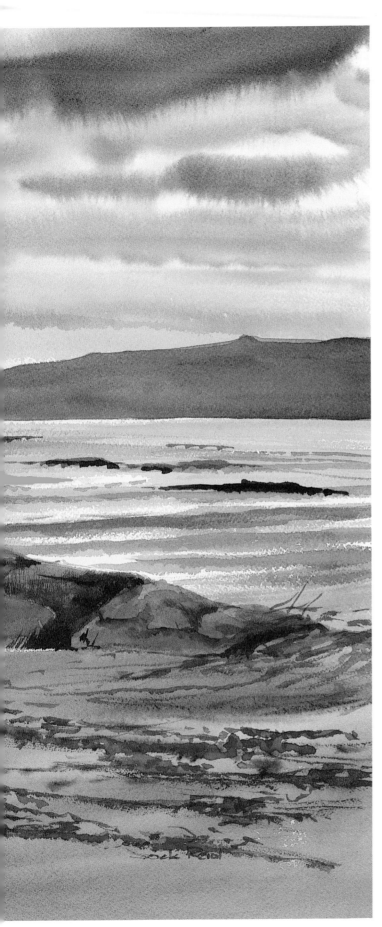

INTRODUCTION TO VALUE

N ow that you have some familiarity with the different techniques—flat and graded washes, wet-in-wet and dry-brush—this chapter will emphasize the importance of tonal value.

What is value in terms of color? Value is simply the strength or intensity of a color. The higher the value the more intense the color. An azure daytime sky has a lower (lighter) value of blue than a clear midnight sky. The value of the color you use is far more important than color itself because, by controlling the value of just one color, you control depth and contrast. When you control those two things, you can subtly control how your painting will be viewed. Color is still important, but the interplay between shadow, depth and contrast is crucial to any painting or drawing.

Crescent Beach
Near Lunenburg, N.S., Canada
17″×23″ (43cm×58cm)
Watercolor on Arches 140-lb. (295g/m²) watercolor paper
Collection of Mrs. Maggie Reid
Brampton, Ontario, Canada

Workshop in Tonal Value

This is a workshop in monochrome painting: painting with one color. In the following exercises you'll discover how contrasting tones of the same color can help you achieve dramatic effects.

The chart on this page is a value scale from one to eight, with one always representing white and eight representing the highest or deepest value of the color. It doesn't matter how many levels a scale has; it merely illustrates the idea that every color has a range of values from light to dark.

I've used Sepia in this chart but any color's value can be adjusted in exactly the same way. And how is that? If you want to reduce the value (or intensity) of a color, add more water; if you want to increase the value (or intensity), add more pigment. It's that simple. But remember: This takes place in either a mixing bowl or on your palette. Never attempt to add water or squeeze raw pigment directly into your painting.

Keep Your Value Chart at Hand

You will be painting a number of pictures in this chapter, and I'll be making plenty of references to value. I'll tell you when to add water or paint to adjust the values. Keep the value chart at right in the front of your mind. Throughout the book I'll periodically say to mix a color or colors to a value of, for example, three. By referring to the value scale above, you'll know approxi-

mately what shade of mixture I'm asking for. You can also make a simple black-and-white photocopy of the value chart and pin it up in your painting room for quick reference.

How to Adjust Value

We will use two methods of value adjustment: (1) adding extra pigment to our mix; and (2) glazing. Glazing, or laying one coat or wash of paint over another wash after it has dried, is the most common method of increasing value.

Keep in mind that you use only one color, Sepia, in all the following exercises. The only difference is the value of Sepia. All illustrations are approximately 5″ × 7″ (13cm × 18cm). I've tried to keep these exercises as simple—and fun—as possible. The subjects are all things I have seen.

Time to Start

Enough theory! I've learned that excessive analysis produces artistic paralysis. See for yourself how the following series of illustrations come to life simply by adjusting the values in the monochrome paintings.

Practice
Pick a color, any color, and practice adding water to it until you can control the values.

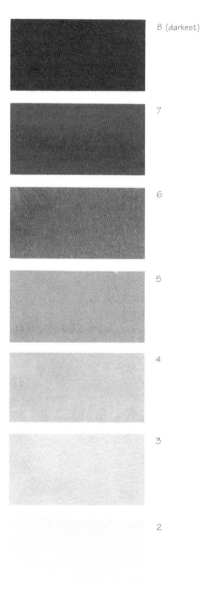

8 (darkest)

7

6

5

4

3

2

1 (lightest)

Value scale in Sepia.

Exercise One: Church Window

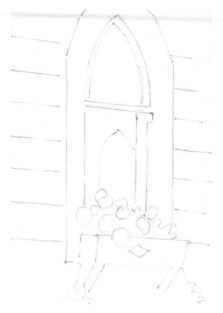

Step 1: Pencil Sketch

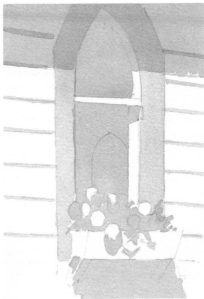

Step 2: First Value Wash
With a value of about three, paint the window and frame, some detail around the flowers and the shadow of the flower box. When dry, use the same value and glaze in the shadow of the building along the top and the shadow of the clapboard.

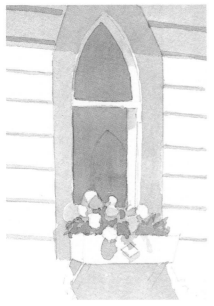

Step 3: Glazing for Detail
Still using the same value, add detail to the flowers with a pointed brush, again by glazing. Notice how this bumps the value up to approximately four or five on our scale. We all know flowers come in different colors; that's why we're painting them with different values—to suggest this color contrast.

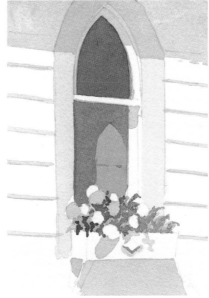

Step 4: Final Glaze
Using a value of about five, paint over the window again with a ½-inch (12mm) square brush, being careful not to paint over the other church window showing inside. By not painting over the second window it stays at a lower value, and this contrast suggests light is coming through it. Glaze again to add a little more detail to the flower leaves. And that's it—a simple exercise in tonal values!

Exercise Two: Log Buildings

Step 1: Pencil Sketch

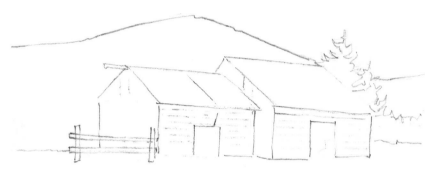

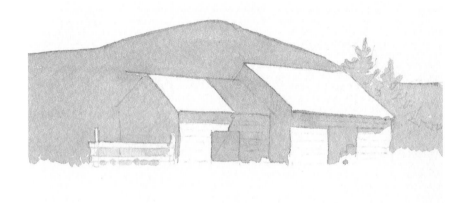

Step 2: Flat Wash
Begin with a value-three flat wash in the areas shown.

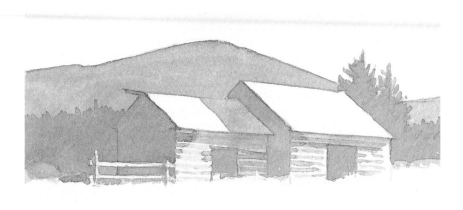

Step 3: Glaze and Graded Wash
Still using the same value, glaze over some of the detailing of the logs in the buildings and background trees with a ½-inch (12mm) square brush. At the bottom, drop in a graded wash but don't bring it all the way up to the building. Be careful to leave a very low value (white) in front of the buildings and on the roofs. This suggests a light source.

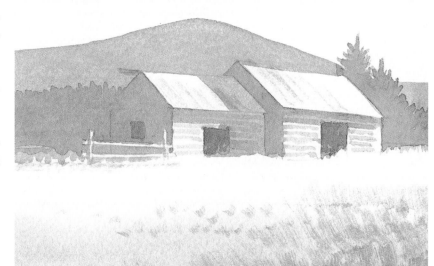

Step 4: Final Glaze and Dry-brush
Still using a value of three, glaze over the doorways, increasing the value to suggest the darkness inside. Using the dry-brush technique and the same mix of value three, stroke in some foreground grass. The sky remains at a value of one, or white.

Exercise Three: Rocks and Water

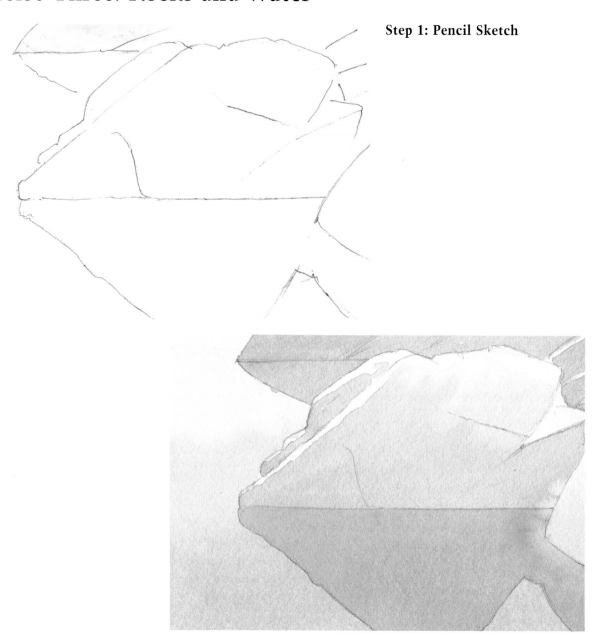

Step 2: First Washes

First lay a graded wash to a value of three on the main rock, leaving the top portion at a value of one and working down toward the bottom of the paper. Once this is dry, apply a value-three flat wash on the main reflection and on the background rocks. Let the painting dry.

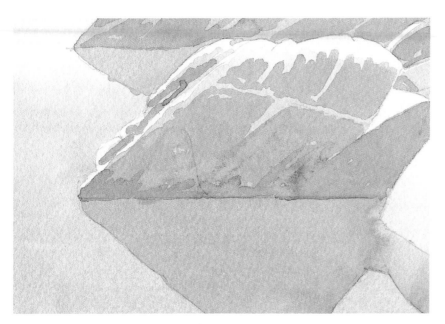

Step 3: Glaze
When dry, continue with the value-three mix and glaze certain portions of all the rocks to enhance detail.

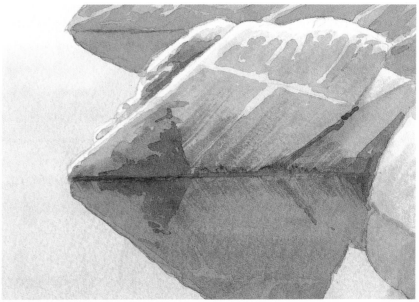

Step 4: Increase Value, Then Drybrush and Glaze
With a ½-inch (12mm) square brush, increase the value to about five and apply some drybrush detailing to suggest rock texture. By applying another glaze over the rock reflections, the effect will be more pronounced.

Exercise Four: Mountain Scene

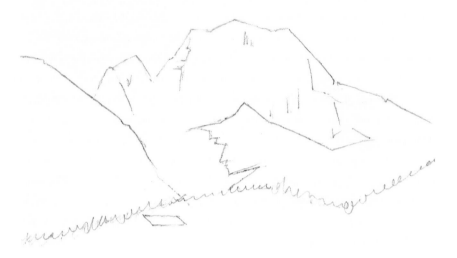

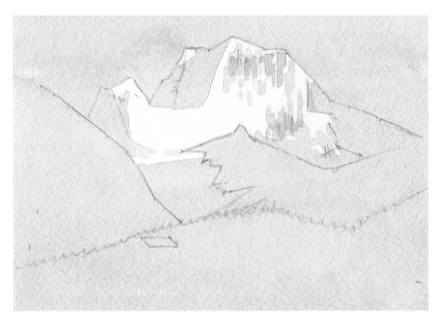

Step 2: Value-Three Wash
Starting with a value-three mix,
apply a flat wash over everything
but the white portions.

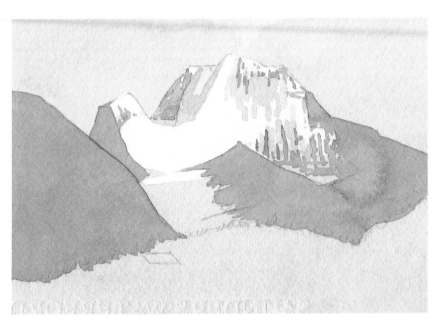

Step 3: Value-Four Glaze

Using a value of four, glaze over parts of the exposed background mountain, the big hill on the left and in the middle ground. Let the painting dry.

Accidents Can Enhance

The scrub lines you see in the sky in steps three and four were actually the result of an accident. I splashed a couple of dots of paint and had to lift them out with a tissue. Accidents happen and I'm far from perfect. If this ever happens to you, don't despair. You can often save your painting by carefully lifting out the blooper. If you're lucky, like I was this time, the accident may even enhance your painting!

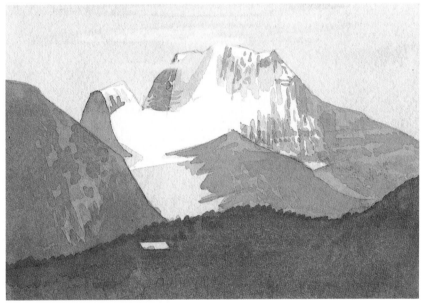

Step 4: Final Glazes

Glaze (again!) over the big hill on the left and the other hills in the middle ground. This increases the value and accentuates the central background mountain. Next, using a value of about six, glaze in the immediate foreground forest, being careful to leave that little square of light value to suggest a building nestled in the woods.

Exercise Five: Barn and Shed in Snow

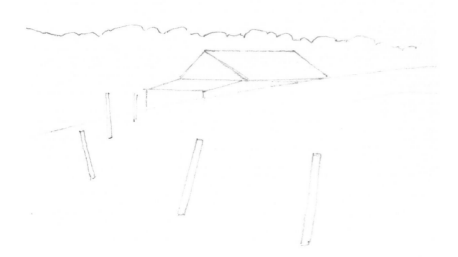

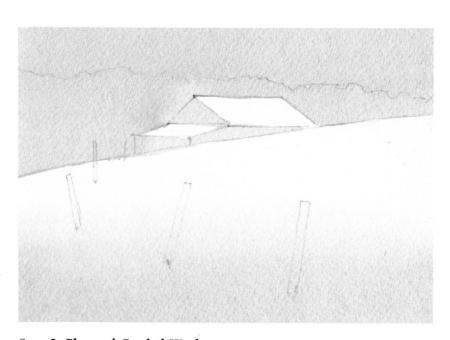

Step 2: Flat and Graded Washes
Use a value of three to apply a flat wash across the sky and buildings—except for the two roofs. Next, using the same value, apply a graded wash from the middle of the picture down gradually toward the base.

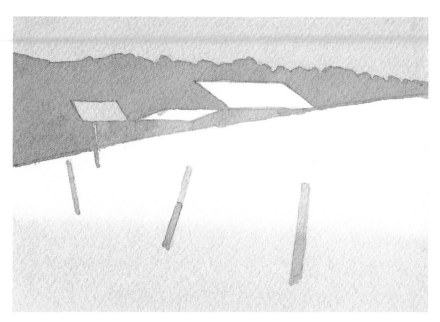

Step 3: Wash

Increase your value to four and wash over the fence posts, the forest in the background and the buildings, carefully avoiding the roofs. Notice I have painted around a third roof. Its value is not as light as the other roofs and less attention is called to it. That's good because I want the main buildings to be the focal point. Notice how tonal values can funnel the viewer's attention to where the artist wants it to go.

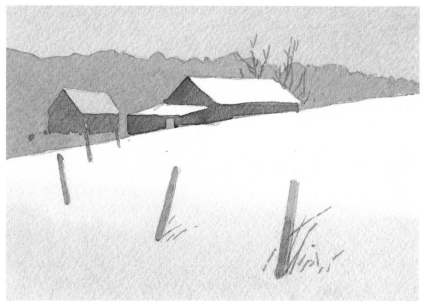

Step 4: Flat Wash for Detail

Strengthening your mix to a value of five, apply a flat wash to all the buildings using a ½-inch (12mm) square brush. Add a tree behind the main building and some grass around the foreground fence posts with a no. 6 round brush.

Exercise Six: Boats at Rest in Mist

This example is a little more complex. I want to challenge you a little at this point.

Step 1: Pencil Sketch

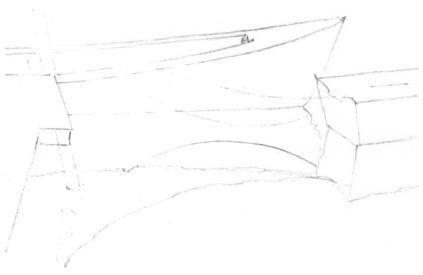

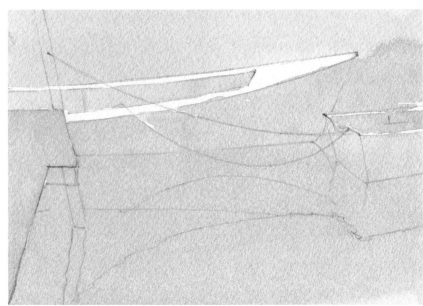

Step 2: First Wash
Apply a flat wash with the value of three to the entire piece of paper except the gunwales of the boats.

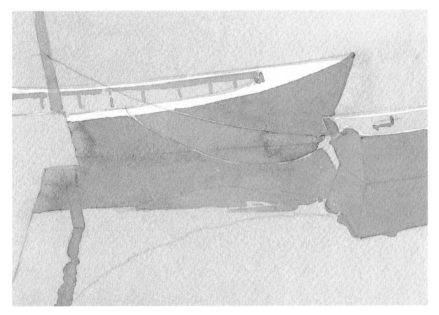

Step 3: Detail and Reflections
After the first wash is dry, use the same mix and brush in the details of the boats, the post to which they're tied and their reflections. You achieve the tie lines by painting around them, not painting them in. It's not a perfect rendering, but we're not trying to be scientifically accurate; we're trying to get the feeling of boats moored in morning mist. Allow the painting to dry.

Step 4: Finishing Details
Still using a value-three mix, drip in the boarding details on the dock. Next, increasing the value of your mix to about five, drip in a flat wash to the side of the main boat. This enhances the value of the main boat, which now commands the bulk of our attention. Then wash in the reflections of the dock, post, boats and tie lines. Use the rigger brush for the tie lines.

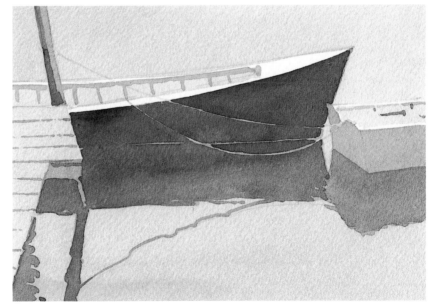

Exercise Seven: Quebec House

This house is located on Avenue Royale just north of Quebec City, Quebec, Canada, a province known for its distinctive buildings.

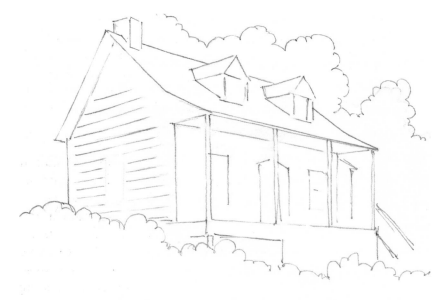

Step 1: Pencil Sketch

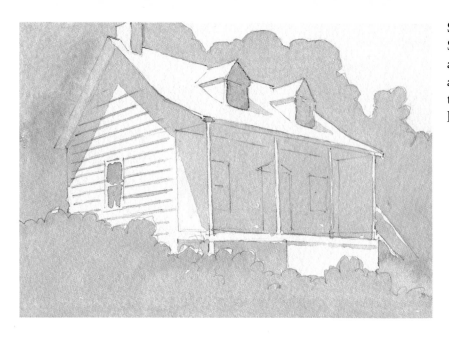

Step 2: First Wash and Shadows
Starting with a value-three mix, apply a flat wash to everything as indicated. When dry, paint in the shadows of the boards on the left side of the house.

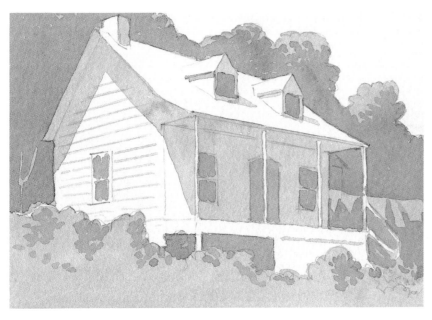

Step 3: Indicate Details

Using the same value, wash in the trees, bushes in front, windows and underneath the porch. Use a no. 12 round brush for the trees and bushes, and a ½-inch (12mm) square brush for the buildings. Notice on the left I have painted around a Y-shaped object. I call this method *painting by omission*, or *negative painting*. You'll see that this object will later turn out to be a tree trunk. I have also used this method to the right of the house to suggest a clothesline flapping in the wind.

Step 4: Final Accentuating Glaze

Going up the scale to a value of six, glaze over the trees and the windows. Notice how the clothes on the line have been accentuated by the darker background.

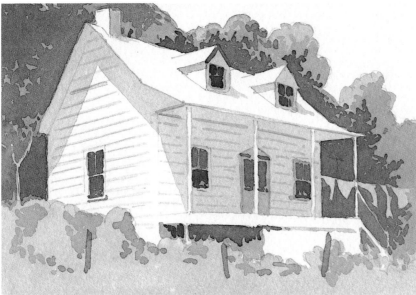

Exercise Eight: Glass of Wine

In this exercise you'll see how the value of one (white) is very important in a painting like this.

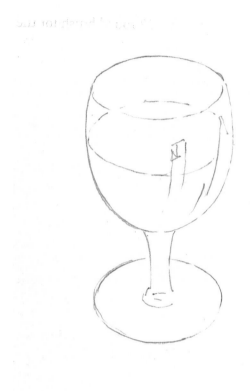

Step 1: Pencil Sketch

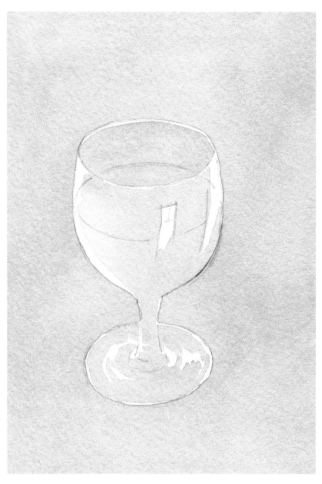

Step 2: Flat Wash
Using a value-three mix, apply a flat wash to the entire picture except for the white parts as shown and let the painting dry.

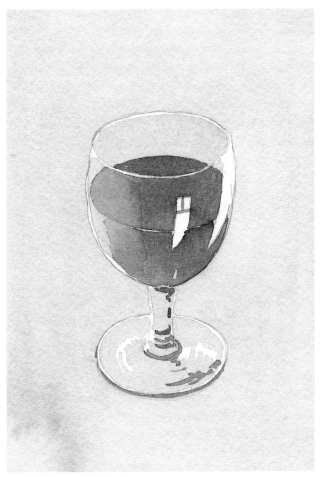

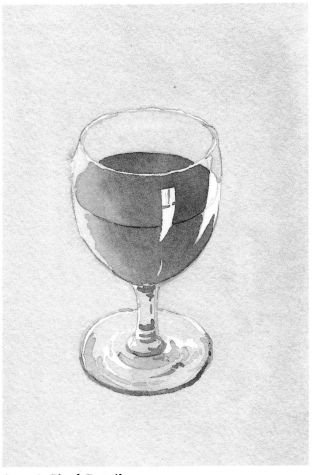

Step 3: Glaze

When dry, increase your mix to value five and glaze in the wine in the glass. Then drop in the slightest hint of shadows around the base of the glass. Be careful to stay off those important white areas.

Step 4: Final Detail

Use a value-three mix to add extra tonal detail to the base of the glass. There seemed to be a little too much white in the top right side of the glass so I dropped in some value three.

Exercise Nine: Grain Elevator

I took a picture of this old-timer in Saskatoon, in the Canadian province of Saskatchewan. I read in the paper the other day that these buildings are being torn down as large farming corporations are storing their grain in central facilities. I'm glad I got a picture of this one before it's torn down. Don't you love progress? Reminds me of the quotation attributed to James Thurber: "Progress was all right. Only it went on too long."

Step 1: Pencil Sketch

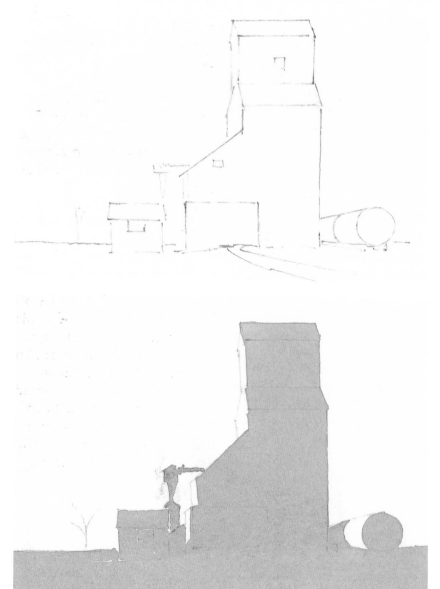

Step 2: Flat Wash
Use a value of three to apply a flat wash to everything as indicated.

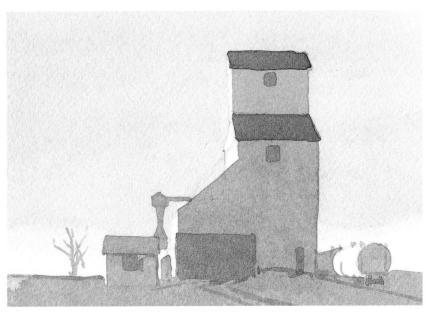

Step 3: Graded Wash

Using a value of two, apply a flat wash that becomes graded as you approach the horizon. Be careful to paint around the white and the rest of the building. Return to a value of four to wash in the roof, road and door details. Remember: Use square brushes to paint objects with sharp corners, and round brushes for round or pointed objects.

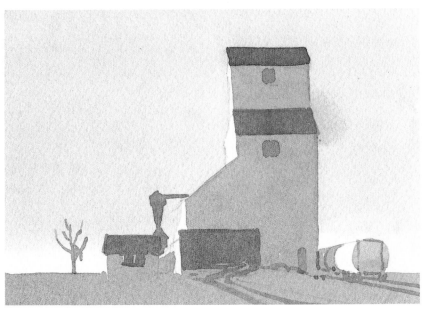

Step 4: Just a Little More Detail

You really could have ended this painting at the previous stage. This happens a lot; when you go through a trial run in monochrome, as we are here, you find that it can be dangerous to add too much detail. So all we're going to add in this step is a little detail to the road and railcars.

Exercise Ten: Distant Hill and Headland

This is a maritime landscape containing about
seven different values. In it you'll find another
example of painting by omission.

Step 1: Pencil Sketch

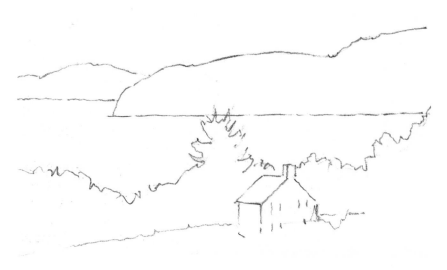

Step 2: Flat Wash
Use a value of three to apply a
flat wash to everything as indi-
cated and let the painting dry.

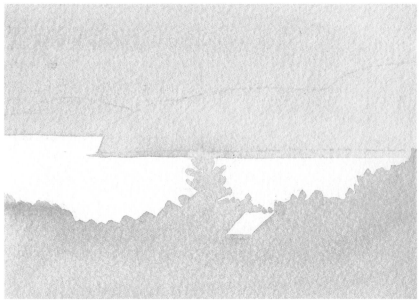

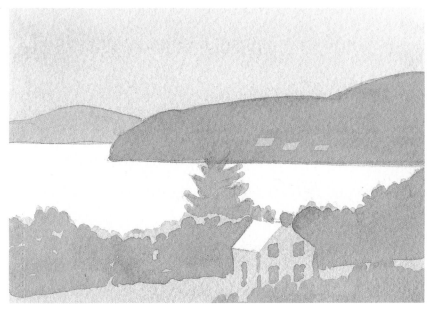

Step 3: Glazing

With a value of about five, glaze the areas as shown, with the exception of those three shapes on the far shore. These will suggest roofs. Using this technique of painting by omission, you can add a lot of detail to a painting without making it look busy. If you'd left the three distant roofs at the same value as the foreground roof, they would conflict and vie for the viewer's attention. By increasing their value slightly, we understate them and keep the focus on the foreground building.

Step 4: Drybrush and Glaze

When dry, use the value-five mix to drybrush the water to give it texture, then glaze over the midground trees. With a mix of value six, glaze in the foreground trees and add some detail to the house. I've also added a tree peeking from behind the house.

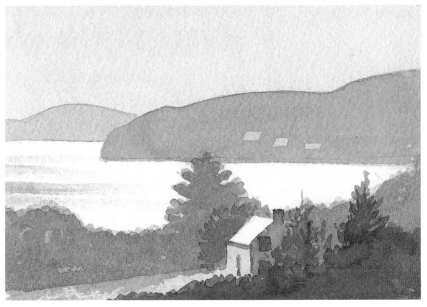

Exercise Eleven: Tree in a Snowy Field With Distant Barn

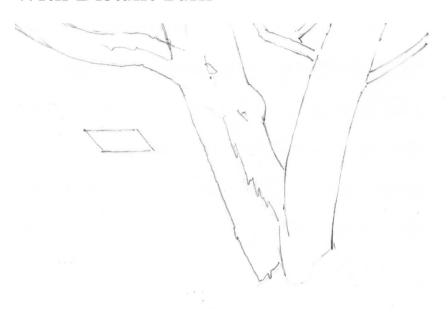

Step 1: Pencil Sketch

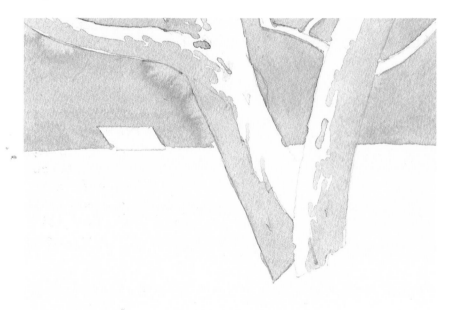

Step 2: Flat Wash
With a value-three mix, apply a
flat wash to the areas shown and
let dry.

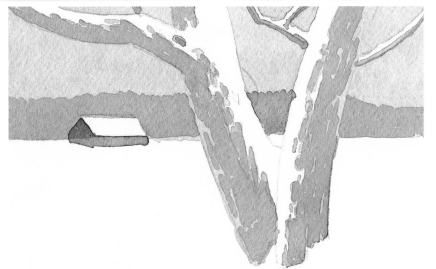

Step 3: Definition

When the wash is dry, use a value-four mix to define the tree line in the distance and to add detail to the foreground tree. Let this dry and then use the same wash to paint in the barn.

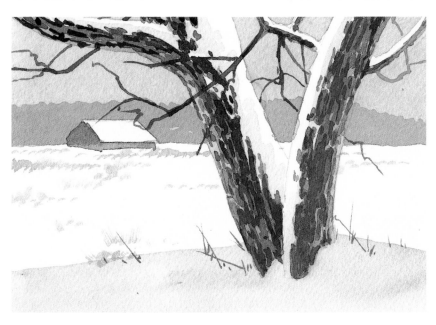

Step 4: Final Wash and Dry-brush

Apply a value-three flat wash around the base of the tree to suggest shadow. With the same value, lay in a wash on the trunk and branches of the tree to suggest shadows being thrown from the snow clinging to the tree. Drybrush in some grass. Finally, moving up to a value of seven, work on the detail of the tree bark and paint in some additional branches and grass poking through the snow at the tree base.

How Far Can You Go?

Now you know how important tonal values are to all paintings. If you practice reproducing different tones in your artwork, it will pay off in a big way.

My philosophy has always been to just jump in. This reminds me of an incident a few years ago. I heard about a fabulous grain mill in a nearby small town. I wanted to go have a look at it but just couldn't find it. As I drove down a dusty back road, an old man wearing overalls and chewing on a piece of straw was ambling along, hands in pockets. Pulling up beside him I asked for directions to this great mill. He pointed to a small side road just ahead, saying, "Go as far as you can see, then see how far you can go."

That old fellow taught me an important lesson: You have to try to tackle projects even though you may have doubts. By the way, I found that mill.

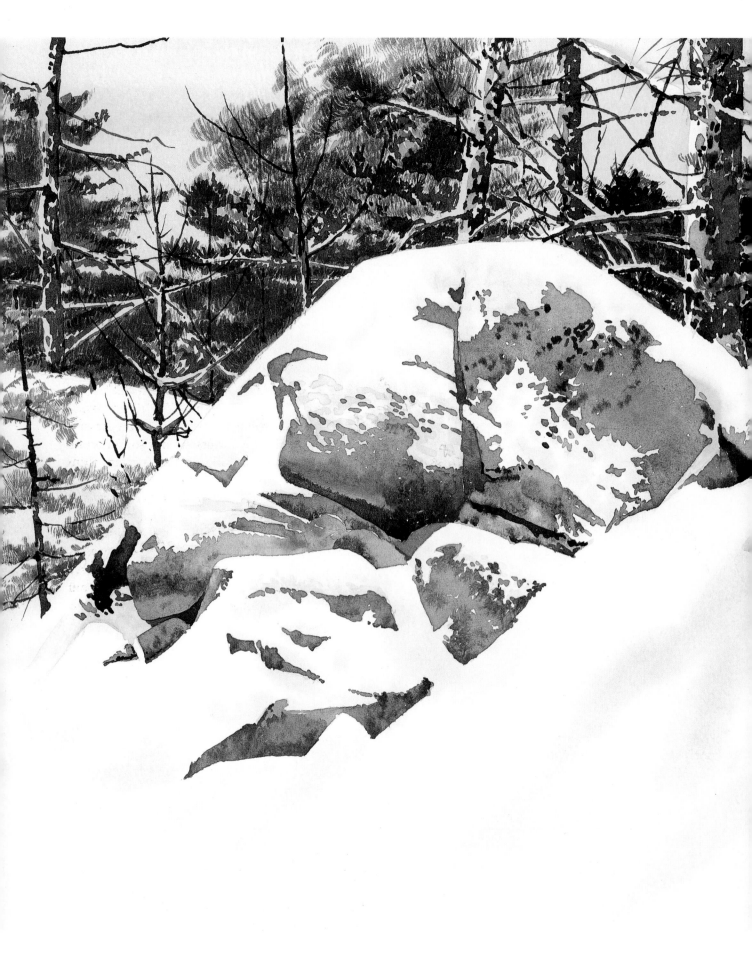

FIVE STEPS TO A PAINTING

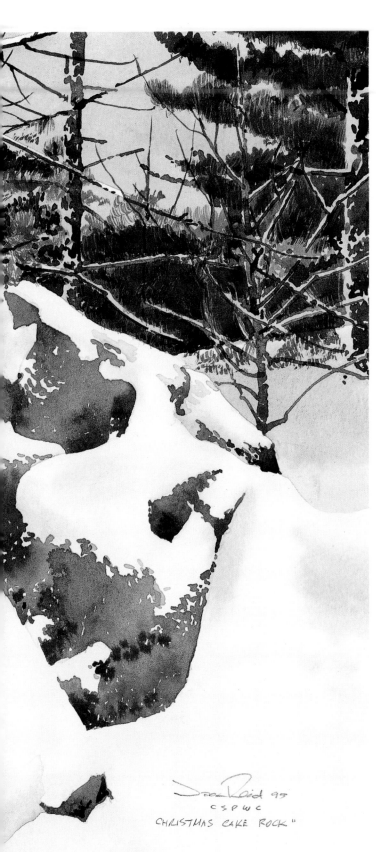

Christmas Cake Rock
Near Bracebridge, Ontario, Canada
14″ × 20″ (36cm × 51cm)
Watercolor on Arches 300-lb. (640g/m²)
rough watercolor paper

Now that you understand the importance of tonal values and some of the striking effects you can achieve by adjusting them, the time has come to experiment with color. The workshop in monochrome paintings in the previous chapter will serve you well here.

You'll notice minor discrepancies in each of the paintings in the following five exercises. I haven't reproduced the objects exactly in each progressive step. Why? Well, the objects are not so important in the workshops that follow; the important thing is using color. So, let's get to it!

In the first exercise we're going to start with a simple monochrome painting of a farmstead at twilight. In the second exercise we'll paint the same scene but with two colors, and so on until we reach the fifth exercise where we'll have five colors on our palette. During these exercises our goal is to perfect our values and develop a sense of color coordination.

Exercise One: One Color

After you've taped a 5½″ × 7½″ (14cm × 19cm) piece of 300-lb. (640g/m²) rough-surfaced paper to the Coroplast, pencil in the drawing below.

Palette:
Sepia

Step 1: Pencil Sketch

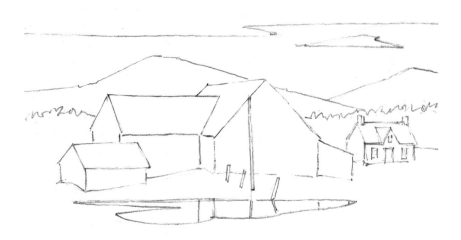

Step 2: Flat Wash

Prepare a value-four mix of Sepia and with your 1-inch (25mm) square brush apply a flat wash to everything except the areas of white—the left sides of the buildings, roofs, the sky and the posts—and, of course, that missing barn board. Remember also to leave one of the house windows white because we want to create the illusion of a light turned on inside. Let dry.

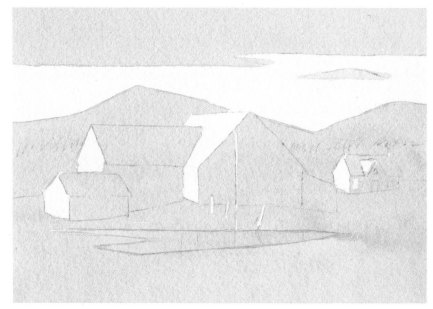

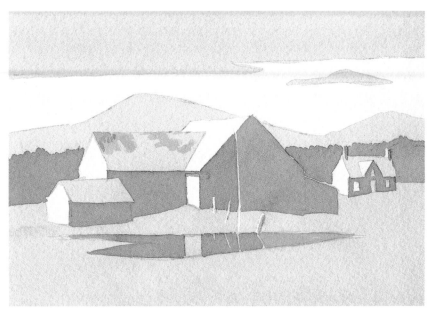

Step 3: Glazing
Using the same value-four mix, load your no. 8 pointed brush and glaze over the trees, buildings, foreground fence post and parts of the puddle as shown. Remember to leave the post reflections in the puddle. Now load your no. 4 pointed brush, gently dab it into clean water to reduce its value and stroke in the blotches as seen on the barn roof. Let dry. Then, using the value-four mix, glaze over the same area, as shown, near the apex of the roof. Let dry.

Step 4: Final Glazes and Details
Still using the same mix, use your ½-inch (12mm) square brush to reglaze the barn with gentle vertical strokes to suggest missing barn boards. Since we have changed the appearance of the barn, we must follow suit with its reflection in the puddle. Let dry.

Now, with the same mix, use your rigger brush to paint in the posts; then, using the appropriate size brush to fit the area, glaze over the window in the shed on the left, the small extension on the right side of the barn, and moving over to the house, stroke in the details as shown. Let dry.

Since we darkened the small extension at the right of the barn, glaze in the extension's reflection to increase the value. Next, jump up to the barn's roof and darken up the areas shown, suggesting a rusty corrugated surface. Finally, load your rigger brush with some mix, remove the excess and stroke in some grass. Be casual about this. Your grass doesn't have to be exactly like mine. To complete the picture, stroke in a few lines on those leftward-facing walls, giving them some texture.

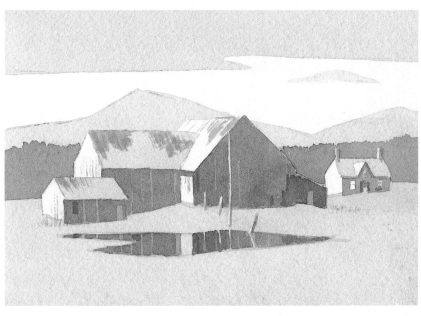

Ready to Move On
Having completed this painting, you can see the power that white commands. With this monochrome painting we have established the values. Now it's time to up the ante and paint this same scene in two colors.

Exercise Two: Two Colors

You know the routine: Tape a 5½″ × 7½″ (14cm × 19cm) piece of 300-lb. (640g/m²) rough-surfaced paper to the Coroplast; pencil in the same basic drawing.

Palette:
Ultramarine Blue
Burnt Sienna

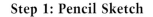

Step 1: Pencil Sketch

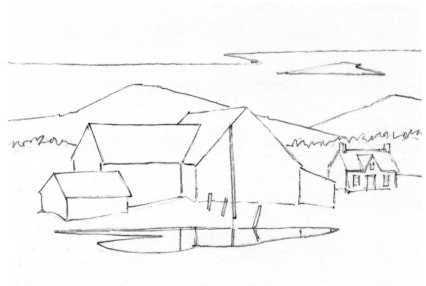

Step 2: Flat Wash

Prepare a value-three wash of Burnt Sienna. Load your 1-inch (25mm) square brush and apply a flat wash to the entire sky, puddle, posts and areas of the buildings as shown. Let dry.

Then prepare a value-three wash of Ultramarine Blue and, with clean 1-inch (25mm) and ½-inch (12mm) square brushes (where appropriate), paint in the mountains, roofs and foreground. Remember to stay off those posts. Let dry. (You'll notice a blue blot on the far side of the puddle. That was a mistake on my part. I sneezed. That kind of stuff happens. I'm not perfect.)

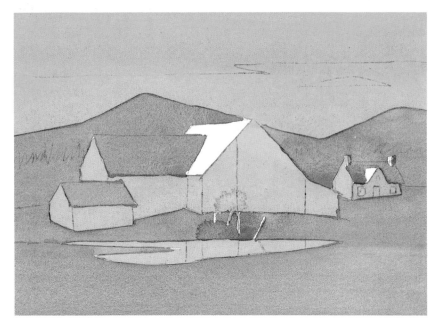

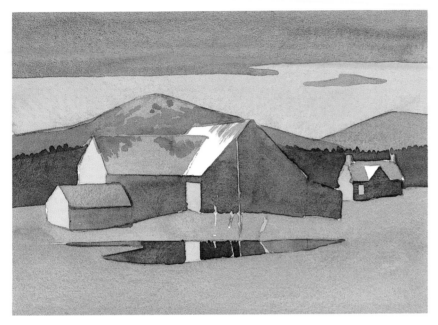

Step 3: Glazing

Using the same mix of Ultramarine Blue, load your no. 8 round pointed brush and glaze the mountains, avoiding areas of the principal peak to suggest snow cover. Let dry.

When dry use a clean 1-inch (25mm) square brush and the same mix to glaze in those areas of the sky as shown. Notice that by painting over the Burnt Sienna with Ultramarine Blue, the color mixes right on the paper rendering a shade of blue-gray for cloud cover.

Now mix equal parts of Ultramarine Blue and Burnt Sienna to a value of about four. That should give you a brownish color. Glaze in the trees, the faces of the buildings and the reflections in the puddle. Let dry. Be mindful not to paint over the lit window in the house and the leftward-facing walls of the buildings, and their reflections in the puddle. Also, remember to leave that missing barn board on the side of the barn.

Once this has dried, go back to the puddle and reglaze. As reflections are always darker than the object reflected, we have to increase the value there in the puddle. And we do that by glazing. Let dry.

Prepare a small value-five wash of Burnt Sienna and, using your no. 4 pointed brush, stroke in the areas shown on the barn roofs to get that rusty look, once again. Let dry.

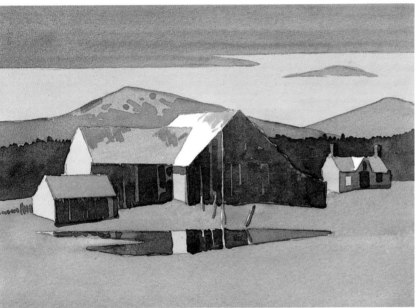

Step 4: Barn Boards

Returning to the two-color mix, load your Sho-Card lettering brush and apply vertical strokes to the barn, holding the brush on its side. This is glazing, once again, and by giving the suggestion of misshapen boards, we kill the monotony of the bland, textureless surface. Next, loading your rigger brush with the same mix, apply some detail to the fence posts (and their reflections), the house face and the two chimneys.

Exercise Three: Three Colors

Prepare to add a third color to your palette—Raw Sienna. This is a dull yellow, but as you'll see, Raw Sienna isn't so dull when complemented with other colors. As usual, sketch the drawing and prepare your palette.

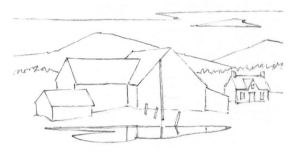

Step 1: Pencil Sketch

Palette:
Ultramarine Blue
Burnt Sienna
Raw Sienna

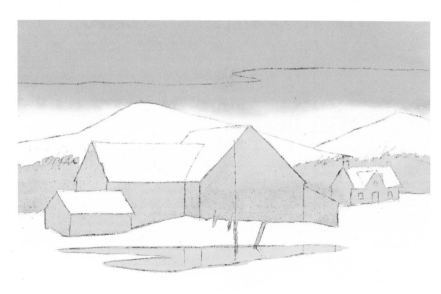

Step 2: Flat Washes
Load your 1-inch (25mm) square brush with a value-four mix of Burnt Sienna and apply a flat wash to the sky. You'll notice that as my sky approaches the mountaintops, the color fades away. To achieve that seamless effect I dipped my brush into clean water, and so switched to a graded wash. Let dry.

Prepare a value-four mix of Raw Sienna and, using a clean ½-inch (12mm) square brush, apply flat washes to the trees, buildings, posts and the puddle as shown. Let dry.

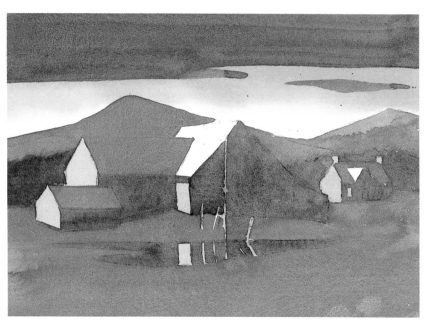

Step 3: Flat Washes and Glazes
Prepare a value-four mix of Ultramarine Blue. This is a little too intense for the effect we want to create, so add a very small dollop of Burnt Sienna to dull it. Now, load a clean ½-inch (12mm) square brush and apply a flat wash to the clouds, trees, foreground, barn, house, puddle and roofs (but not the left sloping parts). Remember to stay off the reflections in the puddle. Let dry. Notice that glazing blue on top of a yellow (Raw Sienna) results in a greenish hue.

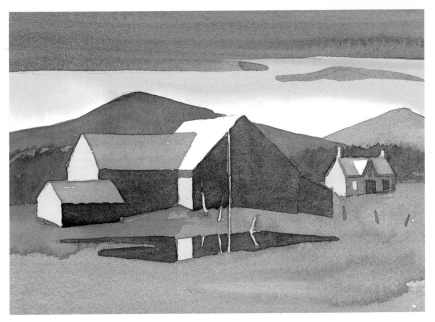

Step 4: Continue Glazing

Using the same value-four mix of Ultramarine Blue with Burnt Sienna, apply a second flat wash to the center mountain and most of the trees, leaving the tree tips untouched.

To provide you with the opportunity to practice deepening the value of snow—one of my favorite subjects to paint—use this mix to apply a flat wash on the snow around the left of the barn and far side of the puddle. Let dry.

Still using the same mix, again glaze over parts of the trees (leaving out the tips) and those parts of the barn and house as shown. Be careful to stay off the posts.

Correspondingly, glaze over the reflections in the puddles, too. Just to make things a little more interesting, paint in a few more posts on the right using this same mix.

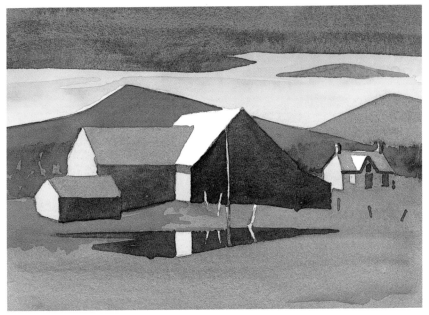

Step 5: More Sky Detail

The remaining white in the sky detracts from the white exposed portion of the barn roof, so I want you to prepare a value-three mix of Raw Sienna and apply a flat wash to the white in the sky, gently overlapping the wash of Burnt Sienna above it.

Establish Values

Compare the finished product with three colors to its counterpart in two colors. The three-color version has brought us closer to the color and value we want. Just remember: We have to establish the values before we can decide on our colors.

Exercise Four: Four Colors

Now we'll introduce a fourth color to our palette. During this exercise let's keep in mind our goal: We want to perfect our values and develop a sense of color coordination. The next, and final, exercise in this introduction to color will involve five colors—three of which will be new. But for now, let's try our hand at using a fourth color—Viridian Green.

Palette:
Ultramarine Blue
Burnt Sienna
Raw Sienna
Viridian Green

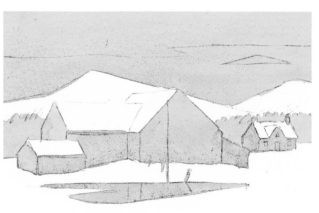

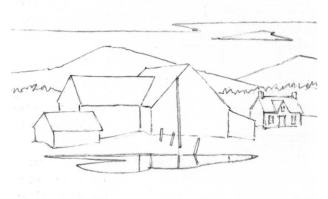

Step 1: Pencil Sketch

Step 2: Initial Wash
Prepare a value-three mix of Raw Sienna. Using your hake brush, apply a flat wash to the entire sky (you can pull off a large wash easier with a hake brush). Next, using your 1-inch (25mm) and ½-inch (12mm) square brushes, apply the same flat wash to the trees, building and puddle as shown. Let dry.

Step 3: Glazing the Sky
Mix equal parts of Burnt Sienna and Ultramarine Blue into a brown-gray to a value of four. Using a clean 1-inch (25mm) square brush, paint in the clouds. To achieve the effect seen in the horizon portion of the sky, mix a high value of Burnt Sienna and glaze in the section as shown. Let dry.

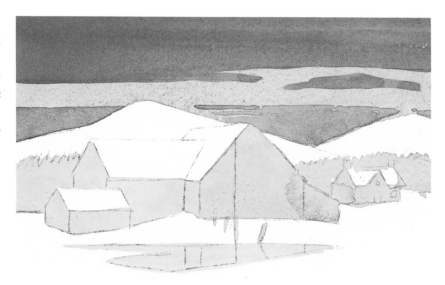

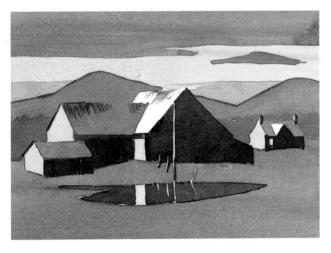

Step 4: Glazes and Blue Wash

As in exercise three, prepare another mix of Ultramarine Blue with a small amount of Burnt Sienna to dull its intensity, and apply a flat wash to all white areas except the leftward-facing roofs of the barn and house. Set this wash aside as you'll need it in a moment. Let dry.

Now mix equal parts of Burnt Sienna and Ultramarine Blue to a value of four and, using your square brushes, glaze over the puddle and left-facing walls of the barn and house. While this dries, load your rigger brush, remove the excess paint, and stroke in the rust detail on the corrugated roof and posts as shown. Let dry.

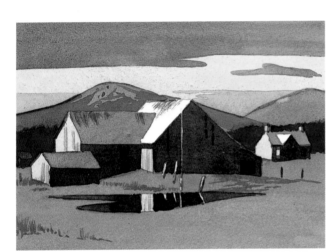

Step 5: Finishing Glaze and Details

Prepare a value-four mix of Viridian Green with a small amount of Burnt Sienna to soften the intensity and, using a no. 8 pointed brush, glaze in the trees.

Use the Ultramarine Blue/Burnt Sienna mix you set aside in step four and glaze over the mountain behind the barn. Leave the crest at a lighter value to suggest snow. You don't want to leave the snow pure white or it will detract from the white on the barn roof.

Go back to your fifty-fifty mix of Ultramarine Blue and Burnt Sienna, load your Sho-Card brush and glaze in the missing barn boards and the openings—on both the barn and house. I've also added a couple of new posts on the right with my Sho-Card brush. Remember to darken the values in the puddle. Let dry.

Mix a small value-four wash of Burnt Sienna and use your rigger brush to stroke in the detail shown on the leftward-facing barn walls, and the corresponding reflections. Then add an equal amount of Raw Sienna to this mix—keeping it at a value of four—and stroke in the grass and mud with your rigger brush.

Prepare for Change

By now you should have a pretty good idea of what this painting is all about. You might be getting a little bored painting the same subject four times in a row, but don't despair. If you've come this far, you've already learned a great deal about color. Prepare for an exciting change to your palette.

Exercise Five: Five Colors

Now that we have refined our values and experimented with various hues and shades, let's go with a five-color palette that will really pull this painting out of the bag.

Because this will be the final version of our subject, I want you to increase the size of your paper to roughly 6½″×8½″ (17cm×22cm). You'll notice I've added three new colors to the palette. Why? Because we want this final version to really sing with color, and I have improved the palette to heighten the effects that, up to this point, we

Palette:
Ultramarine Blue
Burnt Sienna
Rose Madder Genuine
Aureolin Yellow
Cobalt Blue

have only been experimenting with.

Begin by carefully sketching the basic pencil drawing. Remember, this is the final version, so do an especially good job. You just might decide to hang this painting when you're done.

**Step 1:
Pencil Sketch**

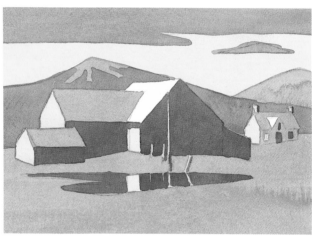

Step 2: Initial Wash

Mix a value-three wash of Aureolin Yellow with just a tiny amount of Rose Madder Genuine so it's not a pure yellow. Apply a flat wash to the entire sky area and other parts of the picture as shown. Let dry.

Step 3: Flat Wash and Glazes

Prepare a value-three mix of Cobalt Blue with a tiny bit of Rose Madder Genuine, which will give the mix a slightly purple cast and warm the cold intensity of the blue. Apply a flat wash to the clouds, mountains and buildings, but stay off the puddle reflections, left-facing roofs and walls. Let dry.

Then glaze over the principal mountain as shown, remembering to paint around a small area at the peak to suggest snow cover. With a value-four mix of equal parts of Ultramarine Blue and Burnt Sienna, glaze in the shadow areas on the barn, posts, puddle and the door, windows and chimneys on the house. Let dry. Keep this mix handy because you'll need it in a minute.

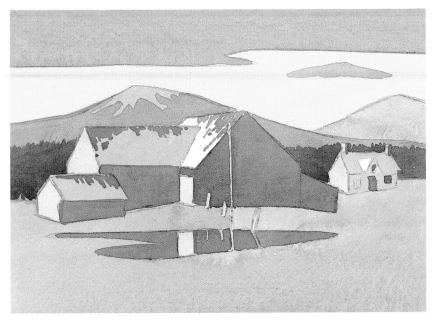

Step 4: Detail

With a value-four mix of equal parts of Aureolin Yellow, Cobalt Blue and Burnt Sienna, glaze in the trees as shown. Now prepare a value-six mix of Aureolin Yellow, Rose Madder Genuine and Burnt Sienna in equal parts. Burnt Sienna on its own won't give us the luminosity we're looking for. Now paint over all the rusty areas of the corrugated roof.

Summary

If you've been diligent in following these exercises, you will have learned the importance of establishing values and something of the subtle relationships between colors. To illustrate this, copy your finished painting from exercise five on a copy machine. You'll find that the photocopy version will be virtually identical to the monochrome painting in exercise one. This should help you to understand how values are the foundation of any painting.

You're probably pretty tired of painting barns. Don't worry, the next chapter is full of more challenging exercises. And when you've done those, start rooting through your old photo albums—or go outside and nature will surely offer up a subject. Whatever you do, look closely with an eye to tonal value and color. Soon, you will develop your own palette of preference, as I have.

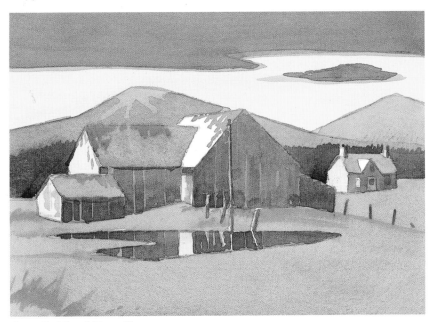

Step 5: Final Detail

With the mix of Ultramarine Blue and Burnt Sienna from step three, glaze in the missing barn boards, paint the house face and edges of the posts, and insert the new posts on the right. Add a little water to your value-six mix of Aureolin Yellow, Rose Madder Genuine and Burnt Sienna from step four, and glaze in those details on the left-facing barn walls. Prepare a value-three mix with equal parts of Aureolin Yellow, Cobalt Blue and Rose Madder Genuine making a grayish hue, and glaze in the clouds. Let dry. Finally, with a value-three mix of Rose Madder Genuine, stroke in the soft hue around the cloud edges.

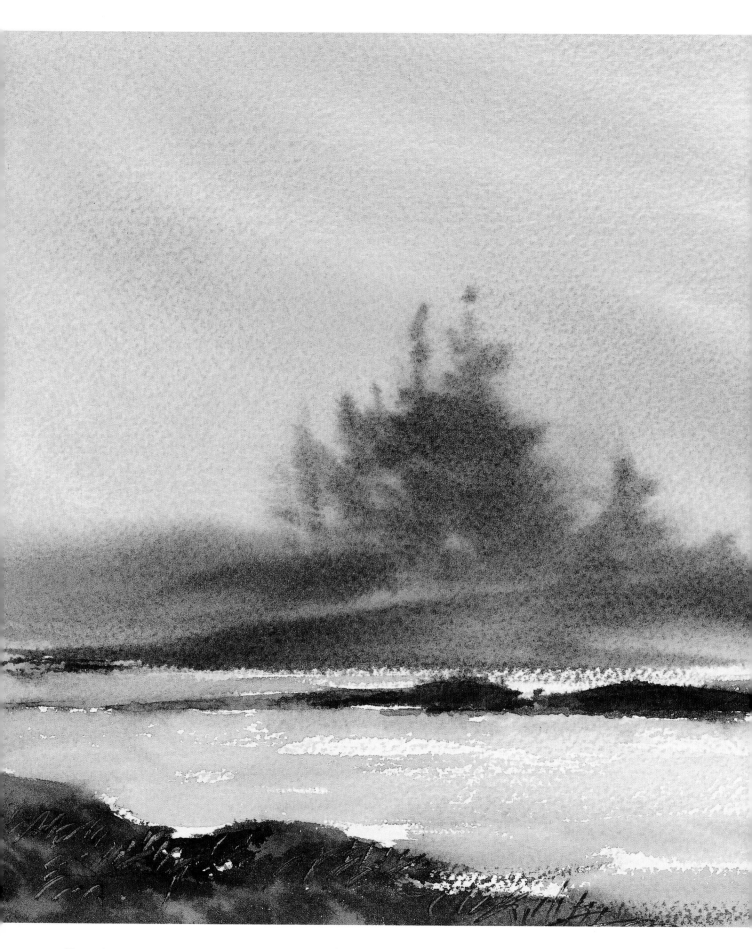

SIMPLE PAINTING PROJECTS

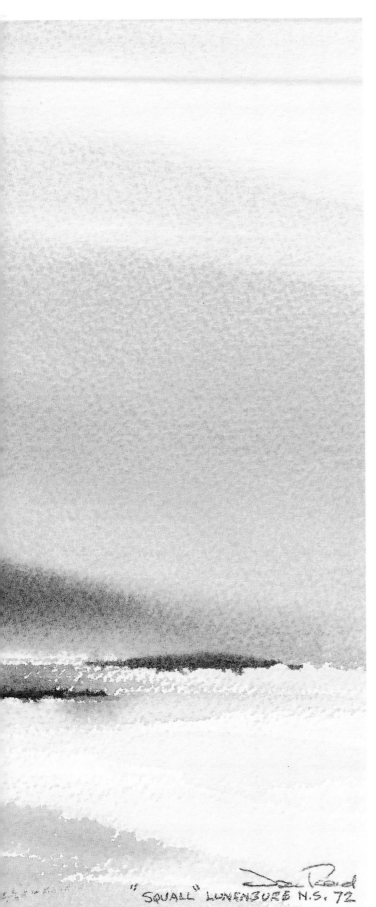

*I*n this chapter I want you to flex your muscles. In some exercises you're going to be painting bigger pictures, and sometimes bigger means harder. I'll be asking you to use more colors than usual and to manage your time effectively in executing wet-in-wets and in lifting pigment from the page. You'll learn how important slight changes in shade and tint are to your painting. I'll teach you a few tricks, and hopefully you'll be more confident. The only way to learn is by doing.

Just remember: We aren't trying to get our works into the Louvre yet. It's okay if you strike out. Babe Ruth did—many times. Any player who hits one in three with regularity is regarded as a legend. Why not paint many pictures with this attitude?

Squall
Near Lunenberg, Nova Scotia, Canada
10″ × 14″ (25cm × 36cm)
Watercolor on Arches 140-lb. (300g/m²)
cold-press watercolor paper

Exercise One: Mist at Dawn

Palette:
Cobalt Blue
Rose Madder Genuine
Aureolin Yellow
Phthalo Green
Alizarin Crimson

Step 1: Pencil Sketch and First Wash
Tape a 5½″×7½″ (14cm×19cm) piece of 300-lb. (640g/m²) rough-surfaced paper to your Coroplast and pencil in your drawing. Then, using your 2-inch (51mm) hake brush, lay a clean-water flat wash over the entire paper surface, using a tissue to lift the excess away from the edges. Move quickly to step two.

Step 2: Wash in the Sky
While the clean-water wash is still moist, mix a light value of Cobalt Blue. Load your 1-inch (25mm) square brush and apply a flat wash to the top portion of the paper. Then load another clean 1-inch (25mm) square brush with a similar value of Rose Madder Genuine and drag a wide wet-in-wet band of this sunset color over the area where blue meets white. Remember to overlap your strokes.

Step 3: Wash in the Mist
Now, do another wet-in-wet as in the last step except drop in a band of Aureolin Yellow. This is our mist. Remember to keep your edges wet so that the colors can run into one another.

Luminous Burnt Sienna?
If something is luminous, it glows in the dark. Burnt Sienna on its own doesn't do this very well, but there are two paints you can mix to achieve this striking effect. They are Aureolin Yellow and Rose Madder Genuine.

Step 4: Wash in the Water

Below the band of Aureolin Yellow drop in a wash of Rose Madder Genuine of the same value as you used before. Finally, as shown in the next frame, finish the bottom by dropping in a mix of Cobalt Blue and Rose Madder Genuine, with a value of about four. Once you've done this, let it dry thoroughly because we are finished with the wet-in-wet technique for now.

Step 5: Background Trees

Make a small wash of the three colors used so far. You should end up with a purple-gray. Apply this mix in a graded wash on the distant trees, using your pointed and rigger brushes for the tops. My mix turned out kind of purple. It's OK if yours is of a little different value.

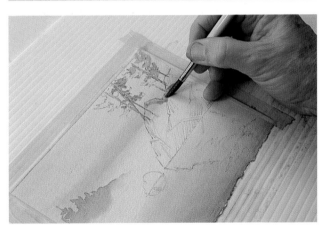

Step 6: Foreground Trees

These foreground trees will be an important element of this picture. The viewing eye will naturally gravitate toward them, and then to the watery shadows they cast. To reinforce the natural prominence these trees have by virtue of their place in the picture, we are going to brush in a particularly eye-catching color—luminous Burnt Sienna. Luminous things glow in the dark. In this picture, just before sunrise, the right side of the foreground trees are still in darkness, but we want them to glow a little with the rising light. Now, you can't buy "luminous" Burnt Sienna, but you can mix two colors to achieve it: Aureolin Yellow and Rose Madder Genuine. Mix these colors, load your pointed brush with a conservative amount, and highlight all the areas on the trees and rock as I have done here.

Remember: Whenever you mix three primary colors together they tend toward gray—and ultimately, black.

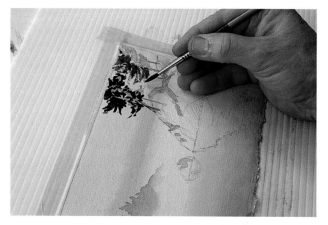

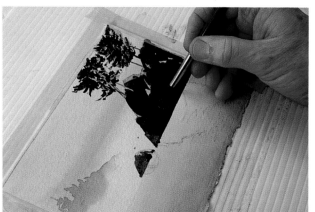

Step 7: Silhouettes

Objects against light are always dark. Therefore, we have to make a powerful mix of Alizarin Crimson and Phthalo Green. Whenever you mix these two colors, they tend toward gray, simply because the green is yellow and blue and whenever you mix three primary colors together they tend toward gray—and ultimately, black. So, load a no. 8 round brush conservatively with this dark mix. Utilizing the tip of your brush, carefully start from the branch tips and move in toward the trunks, then change to a larger round brush and continue down over the rock face.

Step 8: Reflections and Shadows

When painting reflections you have to use your head. Nothing adds to a sense of realism more than a properly thrown shadow. Ask yourself where the shadows would naturally fall. Faked photographs are often exposed after experts perform a quick shadow analysis. To paint the shadowy reflections in the water, take the same dark mix of Alizarin Crimson and Phthalo Green and stroke in the reflections. Big objects, big brush; small objects, small brush. Use the rigger brush for the sapling and its reflection.

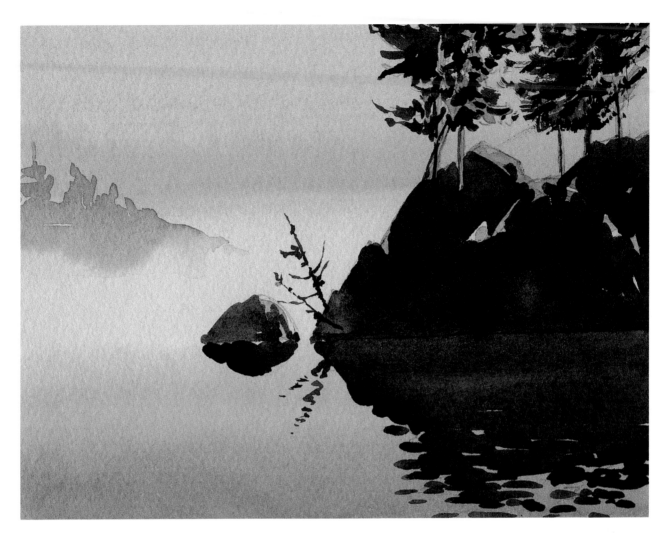

Mist at Dawn
5½" × 7½" (14cm × 19cm)

Lesson Learned?

This exercise illustrated an important point concerning transparent and staining colors. The transparent, "luminous" Burnt Sienna that we added to the foreground rocks and trees was enhanced by the dark staining color we used for the shadows.

When you want any object in your painting to glow, use the four nonstaining transparent colors: Rose Madder Genuine, Aureolin, Cobalt Blue and Viridian Green. The four staining transparent colors (Alizarin Crimson, Transparent Yellow, Phthalo Blue and Phthalo Green) tend to dry somewhat dull, especially when mixed. When other objects in the picture are painted with them, their dullness seems to exaggerate luminosity, as we have seen in this exercise.

Exercise Two: Winter Pond

I periodically have the pleasure of teaching basic watercolor painting to students in Scotland. I recall one student who simply loved painting snow. When I asked him why, he replied, "It's the incredible economy of pigment, paper and motion." I've always remembered that statement, because he understood clearly what painting snow is all about. In this exercise, we'll be painting a lot of snow, and we're going to do it on the biggest piece of paper we've used so far—an 11″×15″ piece of

Palette:
Raw Sienna
Burnt Sienna
Ultramarine Blue
Phthalo Green
Alizarin Crimson

200-lb. (425g/m²) rough-surfaced paper.

There will be wet-in-wet, graded wash and flat-wash techniques involved in this exercise, but graded washes will dominate the overall picture.

Step 1: Pencil Sketch

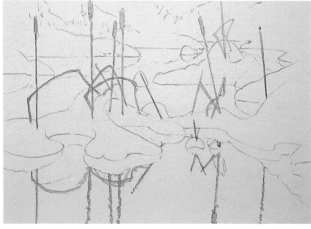

Step 2: Bulrush Stems
Use your no. 4 round brush to mix Raw Sienna and Burnt Sienna to a value of three and apply it to the bulrush stems. Drop in little bits of Burnt Sienna here and there, especially on the pods. Since the pods are a darker shade of brown, you know what you have to do: Add a bit of Ultramarine Blue to the Burnt Sienna. That should give you the deeper shade of brown. Now paint the bulrush reflections exactly the same way except bump up your values a notch.

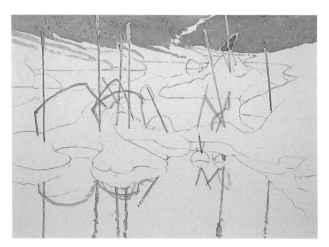

Step 3: Snow-laden Boughs
Mix Ultramarine Blue to a value of four, load your no. 12 round brush and apply a flat wash to the snowy boughs hanging over both sides of the stream. Leave a diagonal sliver of white in the middle section as that will ultimately be a spot where the sun is beating down on the bough on the right.

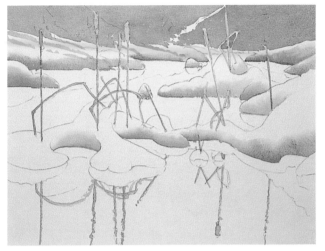

Step 4: Graded Washes

Borrowing from the mix you used for the boughs, do a series of graded washes on the little islands of snow in the foreground. With your no. 8 round brush in hand, start with very clean water and gradually add in the blue. (If you have any doubts about this, go back to the section on graded washes in chapter three and do some boning up.) Make sure your brush work is precise around the shoreline. If you want an idea of what you're painting here, flip ahead to page 98 and have a look at the completed painting; these are the shadows on the tiny snowy islands.

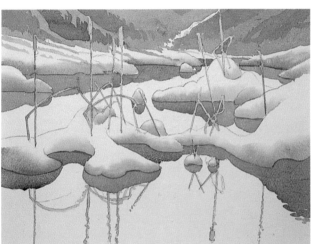

Step 5: Bough Definition and Snow Island Reflections

Still using the same wash, define the boughs of the distant trees at the top with a glaze and complete your snow islands.

Now slightly deepen this mix of Ultramarine Blue by adding Burnt Sienna and, with your no. 8 round brush, paint in all the reflections of the snow in the water. When doing the snow reflections in the background, take care to stay off the bulrushes. This isn't going to be easy, but once you do it, the reward will be a new skill.

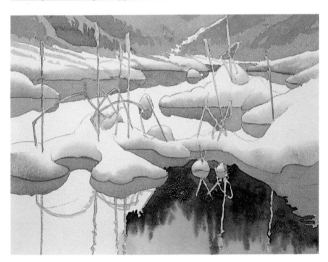

Step 6: Preparatory Step

Mix equal parts of Phthalo Green, Burnt Sienna and Alizarin Crimson. This should give you a very dark, strong green. Have this mix ready and waiting.

Step 7: Surrounding Forest and Sky Reflections

Mix some Ultramarine Blue to a value of four. Turn the picture upside down and, with your no. 8 round brush, drop in a flat wash of blue. I've done it one section at a time, starting with the right-hand side of the picture. Take this wash all the way back to the snow reflections. Again, be careful not to run over your bulrush reflections.

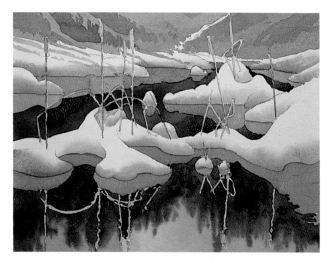

Step 8: Forest Reflection Via Wet-in-Wet
While the section of sky reflection is still wet, take the mix prepared in step six and drop in the dark green, pulling it back in toward the snow reflections. You have to be kind of quick here or else the blue will dry and this will cause a hard edge that we don't want. My reason for doing this one part at a time is that it's easier to control a small area. Be careful not to go over those bulrush reflections!

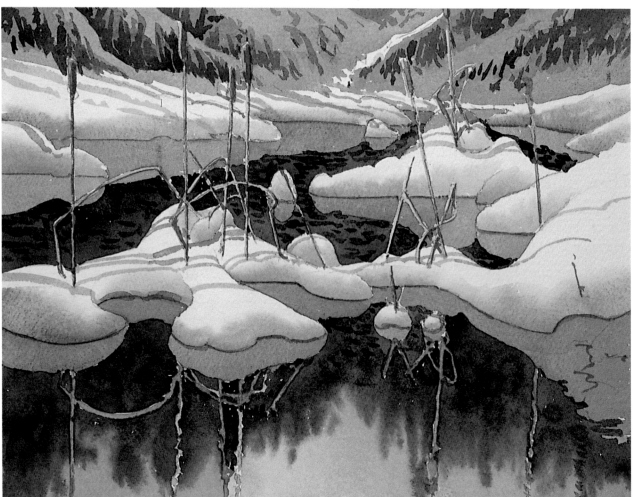

Step 9: Darken the Shadows to Complete Painting

Winter Pond 11″×15″ (28cm×38cm)

With a no. 4 round brush and the same value of the blue-gray used for the reflections of the snow and the snow edge, paint in a dark line—just a thin line to define the bulrushes better. Then take that same value and put little ripple definitions on the water above, between the snow island in the background, and in some of the water in the foreground. With the same green as used in the reflections, paint the exposed green fir portions of the background trees.

Crop for a Simpler Exercise

If this painting has proven too difficult at this stage, I suggest you cut out a small mat, perhaps 2″×3″ (5cm×8cm). (Mine is larger as I'm working with the full-size painting.) Move the mat around the finished painting on the previous page, settling on a simpler perspective. Paint the resulting smaller image according to the preceding instructions. This will allow you to practice the steps of this exercise on a smaller, perhaps more comfortable, scale.

Cut your mat to a size that will give you a smaller, more managable composition that still contains elements of each step in the exercise. My mat is larger, naturally, since I'm dealing with the full-size painting.

Move your mat around the painting vertically . . .

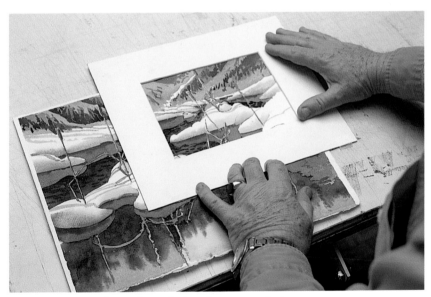

. . . and horizontally until you find an image you feel more comfortable with. Sketch it on your paper and try again!

Exercise Three: Waterfall and Rocks

This exercise will involve moving water. This is a good exercise because it uses a limited palette and lets you practice the basics. Look at the completed picture on page 103 and see if you can identify the techniques before you begin. We'll be using a 5½"×7½" (14cm×19cm) piece of 300-lb. (640g/m²) rough-surfaced paper taped to Coroplast.

Palette:
Viridian Green
Raw Sienna
Burnt Sienna
Ultramarine Blue
Phthalo (or Winsor) Green

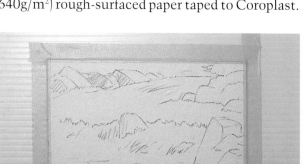

Step 1: Pencil Sketch
This will serve as our basic drawing.

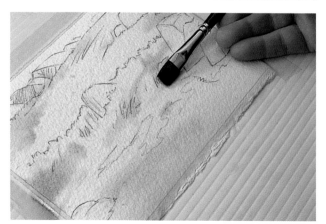

Step 2: Wet-in-Wet
With your hake brush, wash the entire drawing with clean water. Don't be afraid; soak the paper. Shake out the hake brush and wipe off the excess water. Wait a moment or two for the water to soak in. If your paper is quite shiny, it's still too wet. When it has a dull sheen, it's ready for the wash. Drop in the various flat washes of a low value of Cobalt Blue as shown.

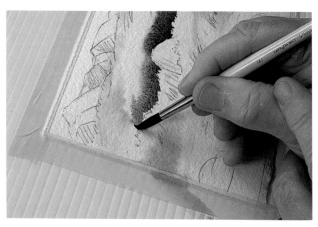

Step 3: Smooth Water
We want to depict some clear, smooth water along the top edge of the breaking foam in the mid-section of the drawing. To do this, make a strong value of Viridian Green. Wash in the midsection with clean water along the top edge, but not the bottom edge because we want that to have a well-defined line. While this is still wet, load your no. 8 round brush with the strong Viridian Green mix and lay in the band of color. While this wash is still wet, drop in some Cobalt Blue as shown in the next frame.

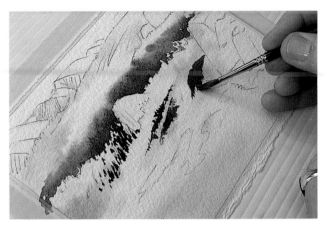

Step 4: Exposed Rock
With a medium-value mix of Ultramarine Blue and Burnt Sienna, load a clean no. 8 round brush and wash in the rocks not covered by the rushing water. Complete the lower edges of the rock by employing a dry-brush technique.

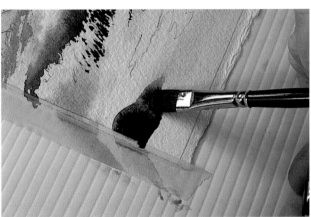

Step 5: Toning the Rocks
Make a mix of Burnt Sienna to a value of four. Load up your ½-inch (12mm) square brush and drop bits of the color onto the top portions of the most prominent foreground rocks. While the rocks are still wet, add Ultramarine Blue to your Burnt Sienna mix, to a value of five, and paint in the lower parts of all the foreground rocks.

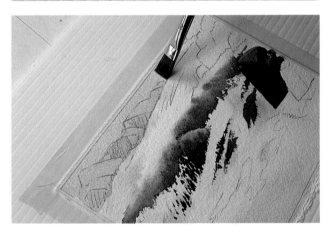

Step 6: Background Rock
Finally, mix Burnt Sienna to a value of four and apply a flat wash to the background area, as you see me doing with my 1-inch (25mm) square brush. When this dries, apply a light glaze of Ultramarine Blue to indicate shadows on the background rocks. (You can see the effect of this in the top left corner of the next step.) Now dry the entire painting.

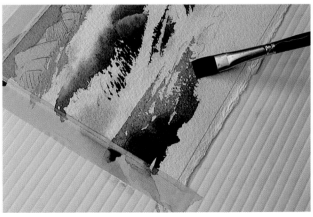

Step 7: Partial Dry-brush for Water
We are now going to work on the bottom portion of the painting. Mix a blue-gray wash of medium value using Burnt Sienna and Ultramarine Blue. Load and then partially unload your ½-inch (12mm) square brush and drybrush the water in front of the white foam. Remember to hold the brush lightly and very flat. Treat it as you would a broom. It isn't going to bite you. Repeat these motions over the whole bottom of the painting.

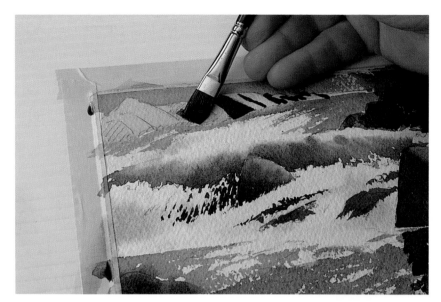

Step 8: Background Rocks

Using a clean ½-inch (12mm) square brush, mix a batch of Ultramarine Blue to a value of five and apply a flat wash to the shadows on the distant rocks.

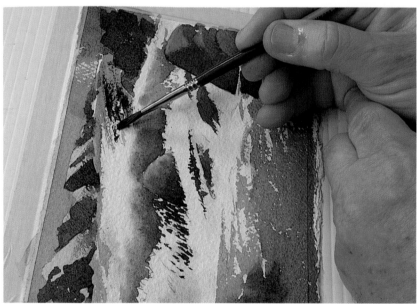

Step 9: Drybrush Water Details

Make a mix of blue-gray using Ultramarine Blue and Burnt Sienna to a value of four. Load and then unload a no. 4 pointed round brush and drybrush the water above the white foam. This will reinforce the impression of splashing water.

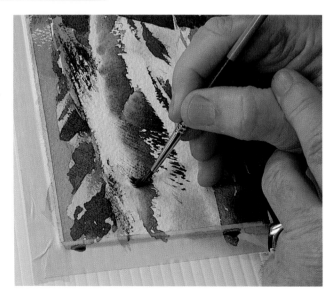

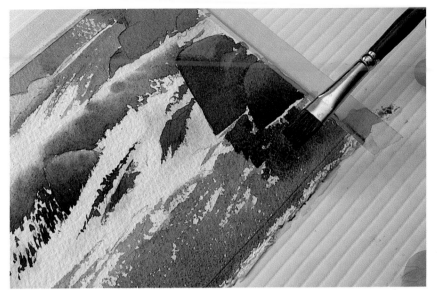

Step 10: Rock Reflections

Using the same blue-gray mix from the previous step, add a little more Ultramarine Blue and paint in the reflection of the rocks on the lower right using your ½-inch (12mm) square brush.

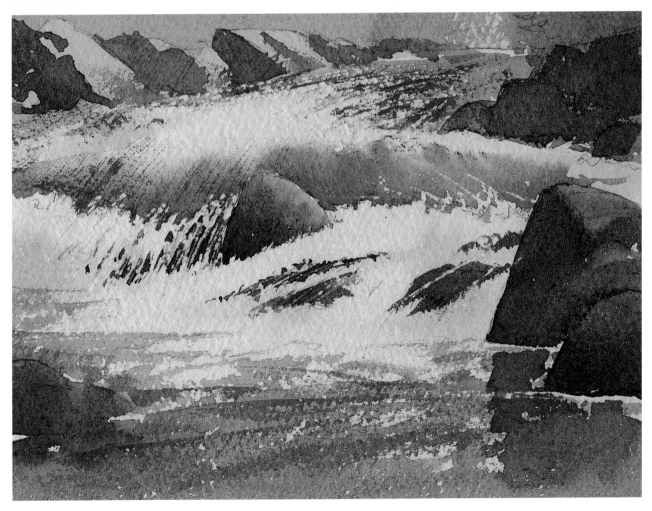

Waterfall and Rocks
5½″ × 7½″ (14cm × 19cm)

Exercise Four: Fall Scene

We'll be using three kinds of brushes in this exercise. This is a good exercise because it emphasizes how effective graded washes can be. We'll use a 5½" × 7½" (14cm × 19cm) piece of rough-surfaced 260-lb. (550g/m²) paper taped to Coroplast.

Palette:
Raw Sienna
Burnt Sienna
Ultramarine Blue

Step 1: Pencil Sketch
Here is your basic drawing.

Step 2: Wet-in-Wet
Load your ½-inch (12mm) square brush with clean water and apply a flat wash of water to the tree by the house, the grass by the fence and by the mailbox. Now, make a light-value mix of Raw Sienna and load your brush with it. Drop in the color where you dropped in the water.

Step 3: More Wet-in-Wet
While the paper is still wet, apply a light value of Burnt Sienna, still using the same brush, to the tree and the grass by the mailbox. Now, clean your brush completely and load it with clean water.

Step 4: Graded Washes
You are about to do a graded wash on the road and on the side of the barn. Starting in the middle of the road, drop in some clean water with left-to-right strokes about 1" (3cm) long. Then stroke in a little band of water along the bottom part of the barn wall. Now make a low-value mix of Ultramarine Blue and Burnt Sienna. This should result in a light brown, which you will now drop in to the left of the water you just brushed into the road and above the water on the barn wall. Remember to overlap the wet edges of the previous strokes. Gradually increase the value of your mix and drop in the rising values until you reach the end of the road at the bottom left corner, and the top of the barn wall. After completing this, lift off any excess paint or water with a tissue.

Step 5: The Tree

Clean the brush you've been using and load it with a light value of Raw Sienna. By pressing and flicking the tip of the brush in a creative manner, you can give contour and form to the tree. Have some fun with it. One of the purposes of this exercise is to provide you with an opportunity to bone up on your brush work.

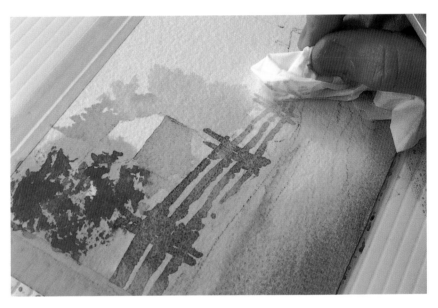

Step 6: Graded Wash on the Fence

Remember the medium-value mix we used for the graded washes on the road and barn? Well, strengthen the value of it by adding a little more Burnt Sienna and, with your ½-inch (12mm) square brush, stroke in the first two sections of the fence boards and post. After you've done this, add a little water to your mix and stroke in the third, distant part of the fence. Soak up any excess with a tissue.

Step 7: Drybrushing

You can see that I've done a little more drybrushing on the tree and am busy here drybrushing in the grass along the bottom of the fence. How'd I do it? Like so: Using a clean no. 12 round brush, load and then unload it with a fairly strong value of Burnt Sienna and complete drybrushing the tree. Use short little upward flicks of the brush to bring the grass to life. As you're drybrushing in the grass, the further along the fence you go, the lighter the grass should get. You do this by adding water to your mix.

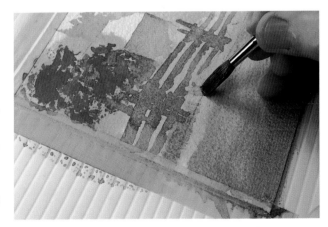

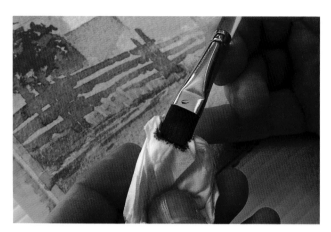

Step 8: Drybrushing the Road

Our road doesn't look very well traveled at this point, does it? It needs some life. You can give it some much-needed texture by drybrushing it. Make a mix of brown with Ultramarine Blue and Burnt Sienna to a value of six. Load and then unload your 1-inch (25mm) square brush using a tissue.

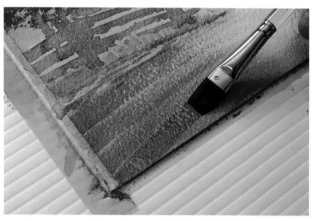

Starting in the bottom left corner, drag your near-empty brush away to the right. Notice the angle at which I am holding the brush: It's very low. For the best dry-brush results, you must keep the brush down near the paper. This allows for maximum contact between the paper and the brush.

Hold the brush upright with just the tip touching the paper as you approach the end of the road since you don't want a lot of paint down there. Remember, we want to give the impression of a misty morning, so we keep that part of the picture at very light values.

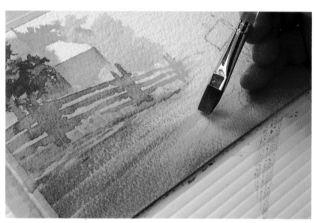

Step 9: Drybrush on Foreground Grass and Barn

Using a medium-value mix of Burnt Sienna, take your no. 8 round brush and drop in a flat wash of grass in the very bottom right-hand corner. Then, using a tissue, fully unload your brush and drybrush the wet flat wash upward to create the impression of shoots of grass around the mailbox. Then apply a couple of downward strokes to the barn as shown to give it some needed texture.

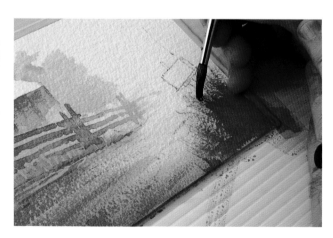

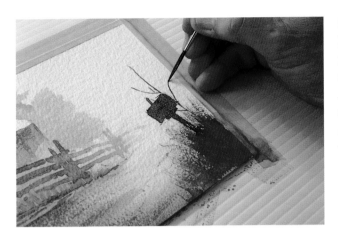

Step 10: The Mailbox

Load your Sho-Card brush with a medium-value mix of Ultramarine Blue with a bit of Burnt Sienna and paint in the mailbox and the mailbox post. After this, add some Burnt Sienna to your mix, strengthening the value. Load your rigger brush and tickle in the plant shoots and leaves around the mailbox.

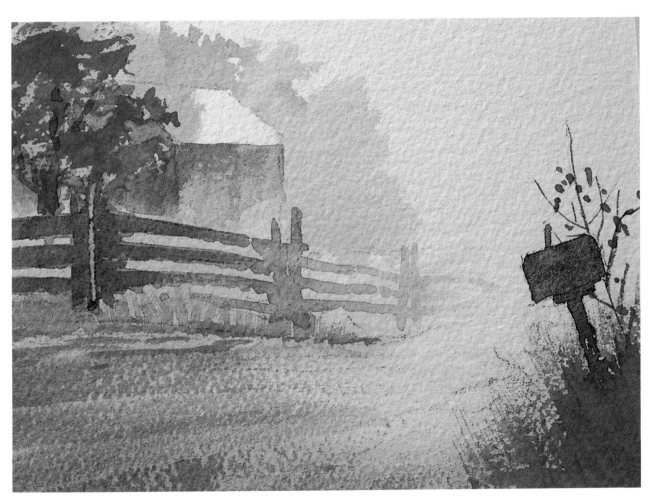

Misty Fall Scene
5½″ × 7½″ (14cm × 19cm)

Exercise Five: Gourds and Pitcher

Let's look at glazing with nonstaining transparent colors and suggesting a light source with a series of graded washes. Use a 6½″ × 8½″ (17cm × 22cm) sheet of 200-lb. (425g/m²) cold-press paper.

Palette:
Rose Madder Genuine
Aureolin Yellow
Cobalt Blue
Viridian Green

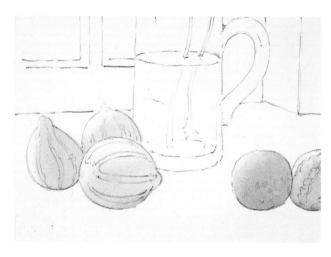

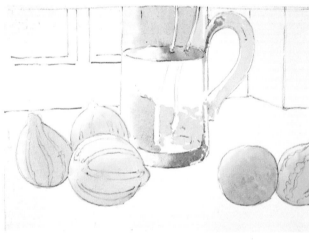

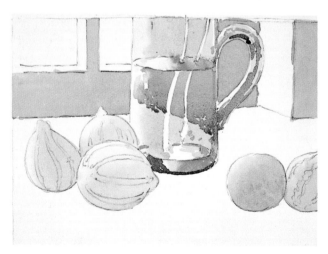

Step 1 (not shown): Pencil Sketch
You know what to do; tape your paper to the Coroplast and pencil in the guide drawing.

Step 2: Graded Washes
To suggest a light source, drop a graded wash on all five gourds so the color value of each gets lighter as we move to the left. For the two gourds on the right, make a light-value mix of Viridian Green and Cobalt Blue. For the others, mix Aureolin Yellow and Rose Madder Genuine, strengthening the value for the far left gourd. Now load a no. 8 round brush with clean water and, on each gourd, paint the area where the light strikes. Then load your brush with the appropriate color and paint the gourds, in a direction away from the light source, overlapping the edges of the previous strokes. I dappled the second gourd in from the right with green (from the Aureolin Yellow/Rose Madder Genuine mix) while the paint was still wet, using a no. 8 round brush. The result of any wet-in-wet is a diffusion of the applied color.

Step 3: The Pitcher
Mix a light-value wash of Cobalt Blue with a bit of Viridian Green. Using your ½-inch (12mm) square brush, drop in a graded wash on the pitcher as shown in blue. Add Viridian Green and Rose Madder Genuine to your mix for a blue-gray, and paint the upper and lower parts of the pitcher.

Step 4: Walls and More Pitcher Detail
Mix a wash of Cobalt Blue, Aureolin Yellow and Rose Madder Genuine to give you a light raw umber. Using your 1-inch (25mm) square brush, drop in a flat wash on the window frames in shadow in the background. When this has dried, add more Cobalt Blue to the mix and paint in the distortion of the back wall as seen through the pitcher. Remember to keep off the standing stems. The detail on the pitcher handle is a mix of Rose Madder Genuine and Viridian Green.

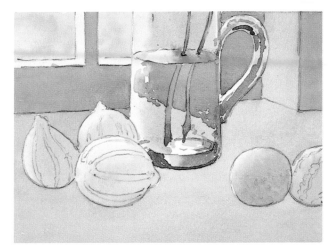

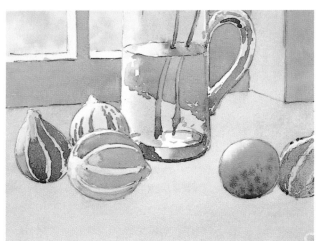

Step 5: Stems and Back Windowpanes

Using the same mix of light green that you used on the gourds (Viridian Green and Cobalt Blue), paint in the stems. You can use either your rigger or Sho-Card brush for this; both are appropriate choices. For the stem bottoms, mix Viridian Green and Rose Madder Genuine to a dull green.

Briskly wash in some clean water on the two windowpanes; tissue up the excess. Now drop in light values of Aureolin Yellow and then Cobalt Blue. This gives a nice impression of sunny glass. Make sure you don't make it too wet, but do let the colors run around in there.

Step 6: Glazing and Gourd Detail

Return to your mix of light, raw umber (Cobalt Blue, Aureolin Yellow and Rose Madder Genuine). Glaze over everything, and I mean everything, except the pitcher, the gourds and the window frames. Start with the windows, then do the walls, then do the countertop, remembering to avoid the gourds and the pitcher.

Now, using your ½-inch (12mm) square brush, detail the gourds with stronger values of the original mixes.

Step 7: Final Reflections

While the glazes in the previous step are still wet, drop in the reflections of the pitcher and gourds with corresponding colors. If you found this exercise was too complicated, you can always choose to paint just a portion of it.

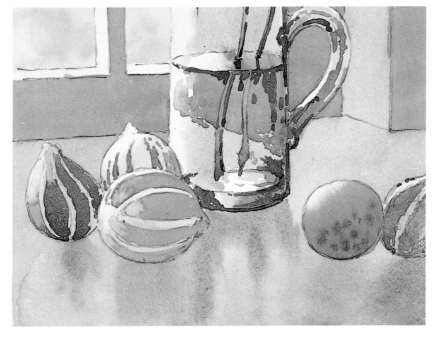

Gourd and Pitcher
6½″ × 8½″ (17cm × 22cm)

Exercise Six: Soft Winter Day

The purpose of this next exercise is to demonstrate the principle of "less is more." We will use only two colors. It's a lesson in simplicity, values, time management and what some say you can't do on a watercolor painting—lifting and correcting. I have not included a pencil drawing with this exercise, but I think you should, just to be on the safe side. Flip to the finished painting on page 113 and base your drawing on that. But, as this painting is loaded with soft-edged objects, don't draw in too

Palette:
Burnt Sienna
Cobalt Blue

many hard lines, and do not draw in the cabin. We're going to do something amazing to get that cabin in there, so pretend it's not even there. The paper for this exercise is a 6"×8" (15cm×20cm) piece of rough-surfaced, 300-lb. (640g/m²) grade. Remember to incline your work surface to 15°.

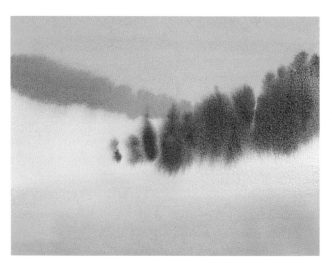

Step 1: Mixes for Sky, Foreground and Wet-in-Wet Trees

Make two separate mixes. The first, for the sky, will be a light-value wash of Cobalt Blue and Burnt Sienna, tending toward gray. In another bowl, mix the same colors but to a darker value, for the stand of trees.

Loading your 1-inch (25mm) square brush with clean water, drop in a flat wash in the midsection of the blank paper. Then, loading the light-value mix, execute a graded wash, darkening slightly as you move toward the top and toward the bottom edge of the page. It doesn't matter which one you do first. Just remember to overlap the wet edge of the previous stroke.

Then, with the upper wash still moist, load your ½-inch (12mm) square brush with the dark-value mix and drop in the trees.

Step 2: Second Stand of Trees

Your work surface should still be moist. You'll have to move quickly. Mix your two base colors to a deeper value of brown and, using your ½-inch (12mm) square brush, briskly drop in the second, closer stand of trees on the right. Experiment with the shades of brown in here, as I have done. Your colors don't have to match mine exactly. Let the picture dry completely.

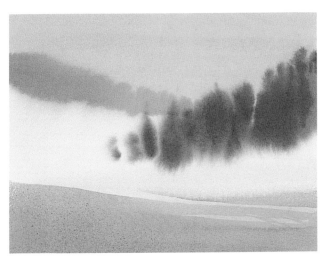

Step 3: Foreground Detail

Using your 1-inch (25mm) square brush, glaze the foreground with a flat wash of the same mix used for the sky. This will appear as snow. Once you've done this, clean your brush, load it with a bit of water and drag it diagonally through the snow. This will create the effect of drifting snow.

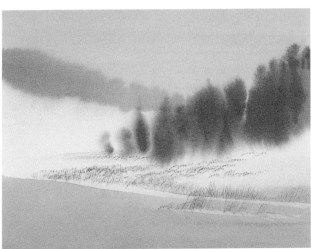

Step 4: Midground Grass Detail

Mix a medium value of brown. Load and then unload your ½-inch (12mm) square brush and with quick, jerky, upward flicks (recall the newsprint exercises), drop in the grass. For fine detail, load your little rigger brush and put on the finishing touches.

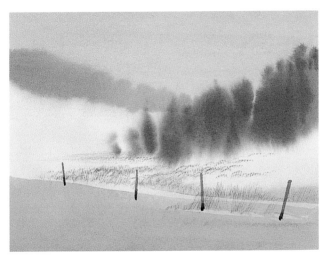

Step 5: Fence Post

Using an even darker value of brown, use your Sho-Card brush to drop in the fence posts.

Lifting and Correcting

Now we are going to do something that many (misinformed) critics of watercolor painting say you can't do—make a correction to a finished painting. In this case, we are going to assume that we forgot to include a cabin in our painting. How do we rectify this oversight? Well, fetch a mat knife and some low-tack masking tape—that's tape that is not very sticky—and follow my lead.

It's a good idea to experiment with this method in other paintings where there is a diffusion of color—that is, where there's mist or fog. This method is also useful if you want to remove a birch tree, for example. Simply isolate the object with tape and follow the steps. In the finished painting, notice how nicely the mix of Burnt Sienna and Cobalt Blue released their grip on the paper. I should warn you, however: This method does not work nearly as well on staining colors.

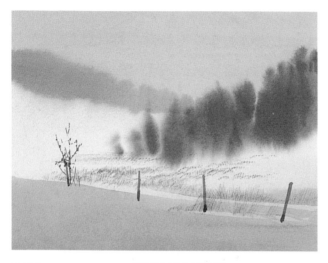

Step 6: Sapling

Use your rigger to paint in the sapling on the end. Let the painting dry completely.

Step 7: Taping and Cutting

Now for the miraculous part. The painting needs to be absolutely dry for this step. Lay down three strips of your low-tack masking tape as shown at left (note: just pat the masking tape), enclosing an area that will be the roof of this cabin. Using your sharp mat knife, score around the roof line, using the inside edges of the tape as a guide. There should be enough left of your drawing of the building to guide you in seeing the roof.

Step 8: Wetting and Lifting

Tilt your work surface toward you at an angle of about 15°. Dip your ½-inch (12mm) square brush in clean water. Now, apply the brush to the area you just scored around. Wiggle your brush around gently so as to agitate the paint. The idea is to loosen the paint's "bite" on the paper. You should have to agitate the area for only a few seconds, depending on the paint. Once you've finished your wiggling and agitating, quickly press a tissue in the area and the paint will lift right out. Now you know that certain pigments can be lifted.

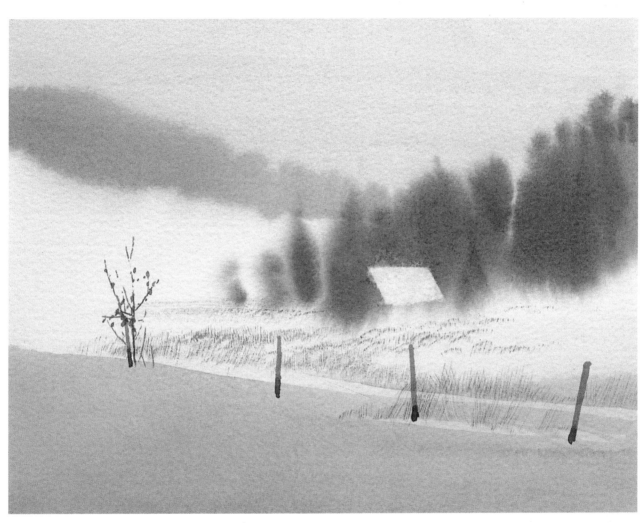

Soft Winter Day
6″×8″ (15cm×20cm)

Exercise Seven: Glacier National Park

This will be an exercise in values. You will be lifting color out and glazing over existing color to control value. Removing a little value with a tissue will suggest cloud cover; adding a little value will create a depth dimension to the picture. The effects are quite startling, and the method is very simple—and fun.

I'm using a 7½″×11″ (19cm×28cm) block of

Palette:
Cobalt Blue
Burnt Sienna
Raw Sienna

paper, but I've cropped the working page to 6½″×8½″ (17cm×22cm) because I like that size and it gives me some room around the edges. I'm using rough-surfaced 260-lb. (550g/m²) cold-press Winsor & Newton paper.

Step 1: Pencil Sketch
Sketch in the basic drawing.

Step 2: Graded Wash for Sky
Make a low-value gray wash using Cobalt Blue and Burnt Sienna. Using your no. 8 pointed brush, begin by dropping in a band of clean water in the top section and gradually drop in your light gray wash. Be careful to paint around the mountains.

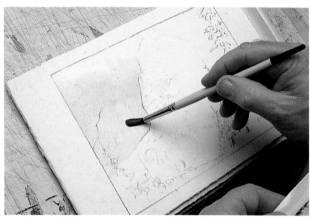

Step 3: Lift Out Clouds
In order to suggest clouds, lift out the bottom right portions of your graded wash (indicated by the brush tip) by gently applying a tissue to the area. If you have difficulty visualizing clouds at this early point in the drawing—or anything else in this painting for that matter—turn to page 117 and take a peek at the finished picture. You will see the quite believable effect that this lifting process will have and the importance of visualization.

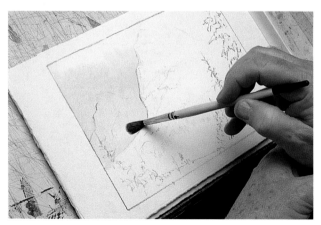

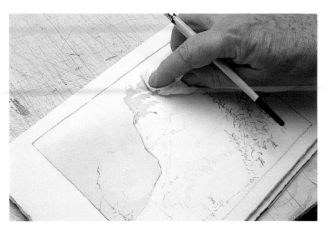

Step 4: Mountaintop

Deepen the same sky wash (gray) and use your no. 12 round brush to stroke in the defining aspects of the mountaintop as I have done. When you finish this, lift out the excess paint with a tissue to lighten the value, again suggesting cloud cover.

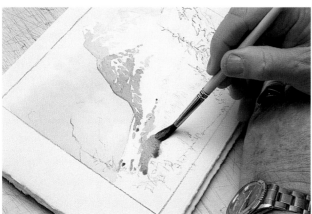

Step 5: Mountain Base

Still using the same wash and brush, add Burnt Sienna to the wash above to make it darker and warmer. Paint in the base detail but don't lift out the excess paint. Also drop in the stand of distant trees at the bottom of this portion of the mountain. Let the picture dry completely.

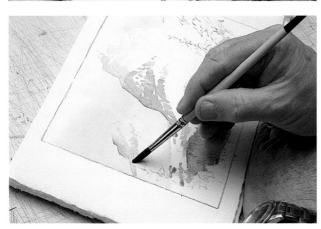

Step 6: Background Mountain and Tree Lines

Make a low-value mix of Cobalt Blue and Burnt Sienna—the same as we used for the sky except weaker. Now, using a clean no. 12 round brush, paint in the distant mountain on the left, dropping a little water into the peak to get that cloud effect. If you drop in too much water, don't worry, just lift it out with a tissue.

Now, using the same wash, brush in the midground tree line, and when everything's dry, come back and glaze over the tree line with a darker value of gray. I recommend the no. 8 pointed tip brush for this. Do not glaze over the top section of the first tree line or you will lose the sense of distance between the two.

Just a reminder: If the values you choose end up lighter than you planned, you can glaze them many times to strengthen their intensity without a loss in the color's luminosity.

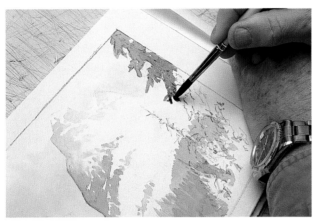

Step 7: Foreground Trees

Mix a medium-value wash of Cobalt Blue and a fair bit of Burnt Sienna. We want the resulting color to resemble the color of snow at dusk. With your no. 8 round brush paint in the large coniferous trees on the right and the smaller ones on the left. They may not look very much like fir trees at this point, but they will. Keep in mind that you are painting the silhouettes of snow-laden trees.

Step 8: Foreground and More Trees

Continue with the same wash to paint in the snowy foreground on the extreme bottom of the paper and the smaller trees on the left. Let the picture dry completely.

Step 9: Glazing and More Tree Work

I hope you're not sick of reading about values, but this is a picture where we have to pay close attention to shades and tints. On this note, you'll have noticed by now that the large fir on the immediate right is closer to the viewer and away from the sun. To really emphasize these facts, we want to darken it up. So, using the same mix as we used in the previous step, go over that big fir again; that is, glaze it.

Next mix Raw Sienna and Cobalt Blue into a dull, dark green. You may want to warm up the mix with just a bit of Burnt Sienna. Now, load your no. 8 round brush (or use the brush that is most comfortable for you) and paint in all the pine trees that we've been working on. Since you are painting branches that are supporting snow, drop the green in under the snowy blue in various places.

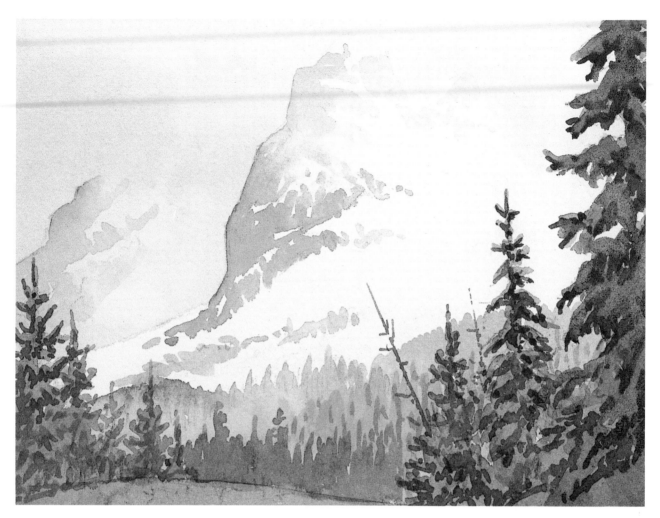

Step 10: Rigger Detail
Make a strong-value mix of Cobalt Blue and Burnt
Sienna to arrive at a moderately strong brown.
Load your rigger with this mix and paint in some
dead trees behind the firs on the right. Also stroke
in a little of this mix underneath the branches of
the fir second in from the right.

Glacier National Park
6½" × 8½" (17cm × 22cm)

Practice Brings Rewards
I hope your painting turned out well enough that
if anyone ever asks you if you've visited Glacier
National Park, you are able to say, "Sure have!"
and proudly display this painting. However, if your
painting didn't turn out so hot, that's OK, too.
You are a better painter after having done this
exercise. Why? Because you did the exercise. If
you keep plugging away at watercolor painting, it
will reward you handsomely in ways you have yet
to imagine.

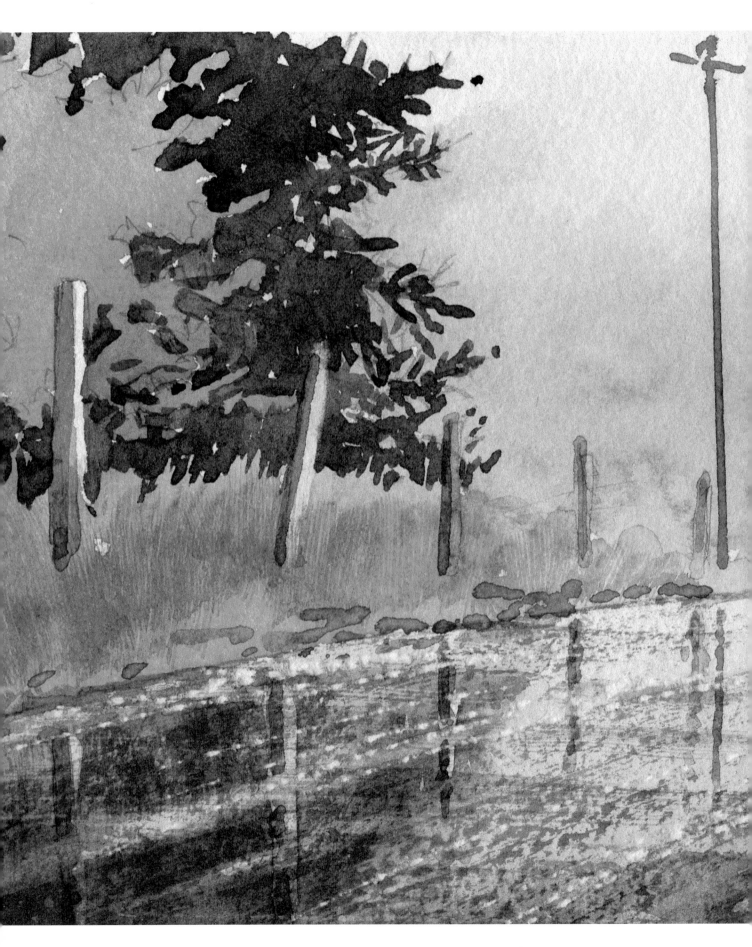

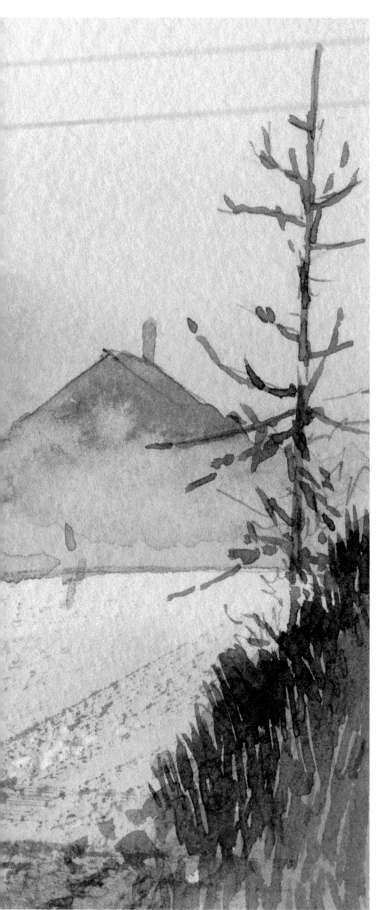

BASIC COMPOSITION

I never studied composition or design in a school or art course, so my message is based on the same message contained in the other lessons in this book: my experience and personal understanding of what makes a picture work.

Simplicity—the idea that less is more—is the first step I use in composing a painting. Let's take an example. Have you ever watched a movie or theatrical production and walked away pretty much indifferent because it was bland and flat, with no distinctive highlights? Well, that's an example of bad composition. Now, recall those movies or plays that you really enjoyed. Something sticks in your mind and it stays there for years. Why? Because there was a strong element involved that dominated the event; maybe it was the actor, the musical theme, the photography or the script. This dominant element stays in your mind because it's stronger than anything else in the production. I'd like you to keep this in mind when you choose your painting subjects. This is what good composition is about: Something in your painting must be stronger than any of the other elements.

Now the process of selection is simple, but simple does not mean easy, as you know; simple just looks easy.

After the Storm
7½″ × 11″ (19cm × 28cm)

Composition Exercises

Whenever you see a potential subject you would like to paint, whether you are seeing it in real life, in a photograph or wherever, it's a good idea to keep the following questions of composition in mind:

- What is it about this picture that attracts me?
- What element do I want to use as the "star" of my painting?
- How do I arrange the other elements in the picture so they don't detract from the star? (Keep in mind that if you have two dominant elements, they might conflict with one another, so you have to decide which one will be the "star" and which the "costar.")

For each of the following exercises, we will begin with a poorly composed picture, with the primary objects placed boringly in the middle. Our task will be to keep the above questions in mind as we attempt to improve the composition of each sample picture.

Water Lilies

This painting is a monochrome study of a water lily. I placed it smack-dab in the center, and as you know, that is a mistake. Let's recompose it so that it leaves a more powerful impression.

Boring central composition.

Here I decided to move some of the elements around for the sake of better composition. I moved the biggest water lily, the dominant element, to the lower left; I moved the second, background water lily away to the upper right. I believe that along with the light patterns and reflections on the lily pads this is a better composition. However, there are other alternatives available for this picture, as you will see in the next sketch.

Here I did the opposite: I moved the main water lily over to the right and the smaller lily a little closer down and to the left. I also deepened the reflections from, say, the trees above this picture. I think this strengthens the focal point and creates more contrast.

Fishing Dory

Here I placed a simple fishing dory casting its reflection of the water and some buildings in the background. The composition is weak and uninteresting; both the boat and the horizon are in the middle of the picture. How can we improve it? Ask yourself the three questions of composition.

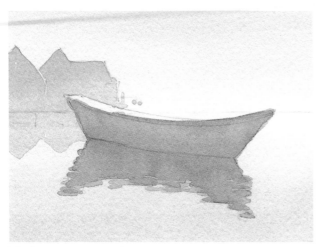

Weak, uninteresting placement.

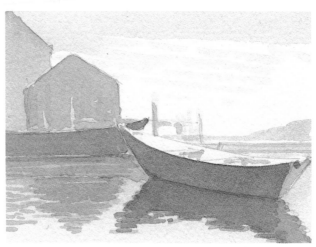

I moved the horizon down, enlarged the buildings on the left, and moved my boat to the lower right pointing into the picture rather than out of the picture. I also exposed some bench detail inside the boat. It is clearly the strongest element in the picture. This is a vast improvement over the original picture.

You see how I revised the values of the buildings in the background; I made them lighter. Notice how the second boat that I added to the picture doesn't detract from the main boat. That's the idea. It's just the costar, and we don't want it to upstage the primary dory. I tried to understate its presence with the use of silhouette.

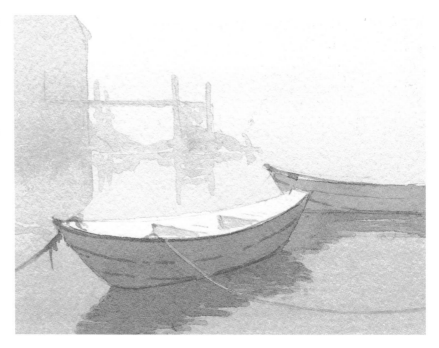

Railway Cars

Unless you want to evoke the moods of bleakness and desolation, you will want to stay away from the composition shown here. By adjusting the elements of this picture, we can come up with a more interesting composition.

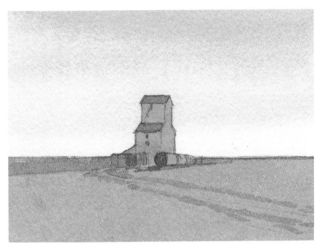

Too bleak, too desolate.

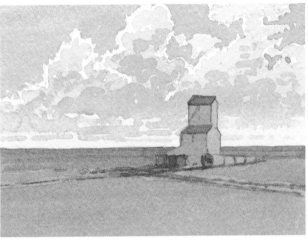

By adding clouds to the featureless sky, the building now has a more interesting relationship to its background. Indeed, the sky threatens to devour the building, thus making it difficult to figure out just what is the dominant element: the sky or the building? A composition decision must be made.

I decided to make the building the dominant element, enlarging it and moving it forward and to the left (never to the center). I darkened the sky in the background to "punch" the building out and give it lots of contrast.

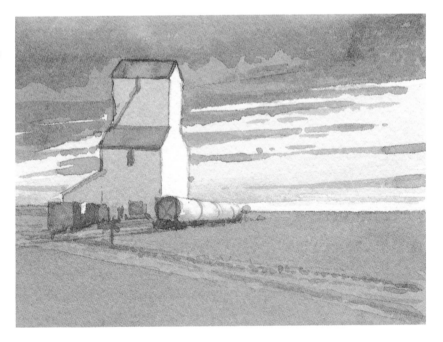

Coastal Study

This is a very simple—and uninteresting—rendering of a cluster of rocks in a tidal pool. Both the horizon and the main focal point of the picture were placed in the center. This composition is not particularly exciting.

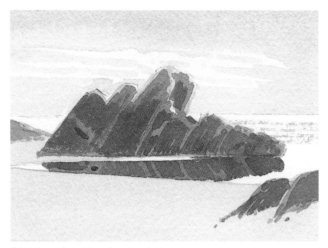

Simple, unimaginative rendering.

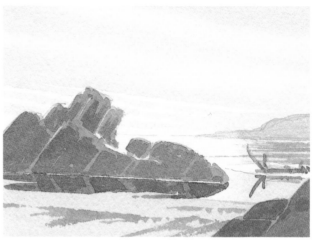

I moved the rock cluster to the left, increased the size of the tidal pool, inserted a headland off into the distance and added drama to the sky. I also put some heavier rocks into the foreground and a small piece of driftwood there on the right. The shape of the driftwood adds a bit of variety to the picture but does not overpower the main subject— the rock cluster.

I like this alternative to the previous composition better. It speaks for itself. I included the element of seagulls. As my dominant theme I silhouetted one of the gulls against the dark rock. The use of reflection is also very effective.

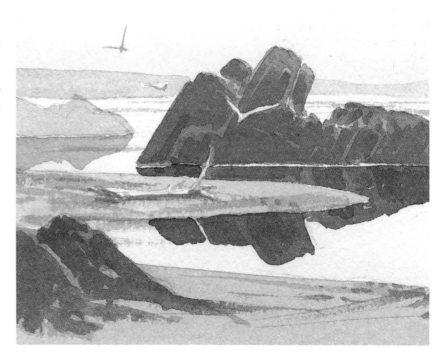

The Use of Photography and Photocopiers

We live in a technological age that has produced sophisticated camera equipment so advanced that we no longer need a course in photography to be able to shoot decent and sometimes quite good photographs. I'm proof of this fact.

An Invaluable Tool

When I first realized it was possible for me to paint for a living, I painted outdoors passionately. Yes, even in the winter and in the rain. But I quickly realized that a camera would be an invaluable tool in helping me to build my own small library of reference material. I shoot many bad photos, which is the price you have to pay to get the special ones. Regard the camera as a tool, just like a brush; it's only as good as the eye of the person taking the photo. I learned to be frugal in my photography, not only in the selection of the picture but in the composition.

Photographic Composition

When I go out with camera in hand, searching for reference photographs, I ask myself questions similar to the three questions of composition we dealt with at the beginning of this chapter. I ask questions such as: Why am I taking this photo? Do I really want to paint it? Am I forgetting what is important in this scene? No other person can see a scene exactly as you do, even if they stand exactly where you stand. We all have different ways of perceiving reality. It's like the quote attributed to the great chief of our First Nations people: "It's a good thing all men don't see alike, or else they would all want my wife."

Once you've learned to take interesting, well-composed pictures, you still have to paint them—and that can be tricky because photos are highly detailed and can intimidate the novice painter. Luckily, there is a technique that can radically simplify the sometimes dizzying detail contained in a photograph: a black-and-white photocopy of the photograph. The following two examples will illustrate the effectiveness of this compositional technique.

Rushing River

If you had to paint from this elaborate photograph, you might have difficulty deciding where to begin. This is a complex scene. However, if you make a black-and-white photocopy of it, values and contrasts become obvious.

After cropping the photocopy, my next step was to do a simple sketch and paint the scene. I want you to understand that by studying the photocopy closely—instead of the photograph—you can tackle a difficult subject.

Snowy Field

Examine the photo at top left, then the photocopy next to it. Notice that there's very little hard-edged shadow and very little contrast. The contrast here is achieved by the definition of the snow-covered branches on the left and, of course, from the weeds that are shooting up—which, by the way, I find very beautiful and serene. The painting, at bottom, has four values—the white snow, the gray sky, the gray on the snowy boughs in the foreground and the dark branches and weeds showing out from under the snow.

So remember: Composition isn't just about where you place the objects within the frame. You must be mindful of contrasts and color intensities, too. As with everything, practice, practice and practice some more.

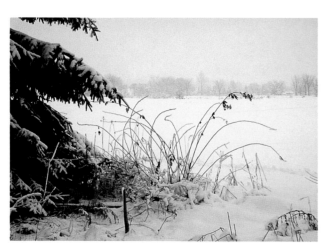 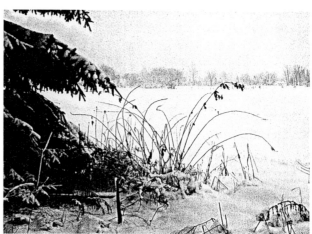

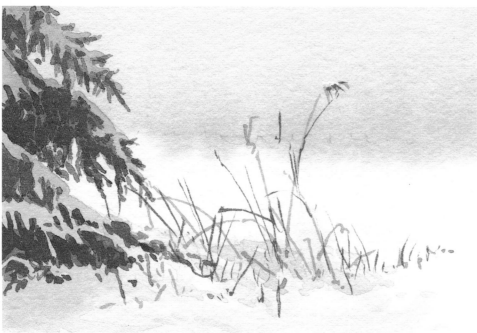

INDEX

More Great Books for Beautiful Watercolors!

Fill Your Watercolors With Nature's Light—Roycraft expands upon his simple and fun masking, paint pouring and spattering techniques to teach you to produce outstanding landscapes and flowers. *ISBN-13: 978-1-58180-039-5, hardcover, 144 pages, #31811-K*
ISBN-10: 1-58180-039-8, hardcover, 144 pages, #31811-K

Watercolor Basics: Color—You'll gain a strong, working foundation for your watercolor painting with a deep understanding of color. Inside you'll find simple language and easy demonstrations to help you find success and get straight to the fun of painting.
ISBN-13: 978-0-89134-886-3, paperback, 128 pages, #31380-K
ISBN-10: 0-89134-886-7, paperback, 128 pages, #31380-K

Light Up Your Watercolors Layer by Layer—This is the must-have advice you need on color theory and the basics of painting light and texture. Demos, color wheels, and call-outs to specific areas of paintings illustrate every technique.
ISBN-13: 978-1-58180-189-7, hardcover, 128 pages, #31961-K
ISBN-10: 1-58180-189-0, hardcover, 128 pages, #31961-K

Painting Spectacular Light Effects in Watercolor—Utilizing 9 complete painting demonstrations, you'll learn how light behaves, where and how to find the best light, and how to use the personality of light to express the feeling and character of a subject. In addition, in-depth guidance features specific instruction for capturing light effects on glass, metal, water, landscapes, and architecture. *ISBN-13: 978-1-58180-589-5, paperback, 144 pages, #33060-K*
ISBN-10: 1-58180-589-6, paperback, 144 pages, #33060-K

Mastering the Watercolor Wash—Clear instructions teach you the four basic color washes: flat, gradated, wet-into-wet, and streaked. You'll find guidelines and 33 demonstrations that combine these techniques to create amazing light, shadows, and textures.
ISBN-13: 978-1-58180-486-7, paperback, 144 pages, #32824-K
ISBN-10: 1-58180-486-5, paperback, 144 pages, #32824-K

These books and other fine North Light Books are available from your local art & craft retailer, bookstore, online supplier or by calling 1-800-448-0915.